The New Gnosis

Heidegger, Hillman, and Angels

Roberts Avens

SPRING PUBLICATIONS, INC.
PUTNAM, CONNECTICUT

Published by Spring Publications, Inc.
28 Front Street, Putnam, CT 06260
www.springpublications.com

Distributed by The Continuum International Publishing Group
www.continuumbooks.com

First published in 1984

New printing 2006

Printed in Canada

Design: white.room productions, New York

Library of Congress Cataloging-in-Publication Data

Avens, Roberts
The new gnosis.

Bibliography : p.
1. Heidegger, Martin. 2. Hillman, James. 3. Angels. I. Title.
B3279.H49A94 1984, 2003 100 84-5297
ISBN 0-88214-328-X
ISBN 0-88214-327-1 (pbk.)

Contents

Introduction: Gnosis

The present inquiry, as the title indicates, is not primarily about Martin Heidegger, James Hillman—the founder of archetypal psychology—and angels (who have never founded anything) but about gnosis as exemplified in the work of these two seminal thinkers. This means that I am concerned not so much with a comprehensive presentation of ideas contained in the works of Heidegger and Hillman as with the subject matter itself embodied in the word "gnosis." It is also this subject matter, the matter to be thought about, that has dictated the selection of relevant passages in our two authors, and my only hope is that the eclectic approach I have adopted will not deviate to any appreciable degree from the essential thrust of their opus as a whole. In addition to Heidegger and Hillman, frequent reference will be made to Henry Corbin's conception of the *mundus imaginalis* (imaginal world)—a realm of angelic beings or archetypal images that provides cosmological grounding for physical reality.[1]

The gnostic element in the thought of Heidegger and Hillman has, fundamentally speaking, nothing to do with the sectarian religious movement of antiquity known as gnosticism.[2] By the same token their gnosis, as the term will be understood throughout these pages, does not imply any *Weltanschauung* or

system of concepts. On the contrary, the aim of the kind of thinking promulgated by Heidegger and Hillman is to destruct the very impulse to imprison reality in a system of concepts which frame it out and circumscribe it. As a result, the most prominent feature these two men have in common is a certain style of thinking or a style of consciousness rather than certain views about the world aiming at overall coherence.[3]

Another characteristic that brings Heidegger and Hillman into close proximity is that the path they have chosen to thread literally leads nowhere. It is as if they were trying, in the wake of Hui Neng, one of the early patriarchs of Zen Buddhism, "to awaken the mind without fixing it upon anything." One might call it a deflating enterprise peeling the hundred integuments of the onion and finding that there is nothing special at its center. In this sense, both Heidegger and Hillman are, in Heidegger's phrase, thinkers in a "needy time"—"the time of the gods who have fled *and* of the god that is coming."[4] Presumably these are also the times when, as W. B. Yeats diagnosed, "the center cannot hold" and "mere anarchy is loosed upon the world."[5] As we shall see, however, Gods are absent in our time only as literalized or hypostatized entities providing security for the ego, and "anarchy" originally means simply "no *archē* or beginning." Thus there would be nothing more alarming about needy times than the absence of a God or Gods in the beginning—as foundational structure(s).

But what is gnosis? John Keats, in a famous letter of 1817, refers to an ability to work with imagination without the necessity of seeking out fact and reason as "*Negative Capability*, that is, when man is capable of being in uncertainties, Mysteries, doubts, without any irritable reaching after fact & reason."[6] According to Keats, there is a kind of imaginative questioning that is more rewarding than finding "fact and reason"—a questioning that involves the questioner in the matter of thought so deeply that he becomes, in a sense, one with it. At this point knowing is no longer divorced from being: we know the way we

2

Introduction: Gnosis

are and we are the way we know. In the Platonic tradition this is expressed in the axiom "like can only be known by like."[7] Our first characterization of gnosis, then, is based on the idea that there is a strict correspondence between knowledge and being. Knowledge or thinking is inseparable from being and vice versa.

We may further clarify this by using the word "gnosis" as the middle term between the traditional categories of "belief" and "reason." Belief (or faith) is usually associated with the emotional function, and reason means ordinary reason or the think-. ing function. In Corbin's view, what is overlooked here is that "between believing and knowing there is a third mediating term" connoting "inner vision," which cosmologically corresponds to an "intermediate and mediating world forgotten by the official philosophy and theology of our times: the *mundus imaginalis*, the imaginal world."[8] Corbin's *mundus imaginalis* is the necessary mediatrix (theologically conceived as *Deus revelatus*, revealed God) between the hidden Deity (*Deus absconditus*) and man's world. It is the world of the soul or psyche which in the Platonic and esoteric tradition is called *Anima Mundi*, the Soul of the World. Gnosis—and this is our second characterization of the word—has to do with the cultivation of the soul. We follow the Socratic commandment: "Give attention to the soul!" For as C. G. Jung has observed, the "real secret" of the gnostics was that "the psyche existed as a source of knowledge just as much as it did for the alchemists."[9] Jacob Needleman, a contemporary gnostic, points out that the important distinction to be made is not between faith and reason, but "between consciousness of one's own states [whether they are called 'reason' or 'emotion' or what not] and the unconscious reactions of both thought *and* emotion. To choose between thought and emotion . . . is to miss the point. Self-attention is the point."[10]

Our third characterization of gnosis follows from the second. In Corbin's words, gnosis is a "salvational, redemptive knowledge, because it has the virtue of bringing about the inner

transformation of man." In contrast to all theoretical learning, it is "knowledge that changes and transforms the knowing subject."[11] As if echoing Corbin, Needleman describes gnosis as "a search for knowledge conducted with such all-round intensity that this search itself becomes an ontologically transforming force."[12] We may summarize the preceding remarks by stating that gnosis unites practice and theory and that good theory ultimately depends on right praxis. To put it in William Blake's words, "As a man is, So he Sees."[13]

In esotericism "salvational knowledge" is called *gnosis kardias*, wisdom of the heart. Heart—*himma* in Islamic Sufism—is conceived here as the locus of the spiritual energy of imagination or spiritual perception; it signifies "the act of meditating . . . imagining, projecting, ardently desiring. . . ."[14] The energy of *himma* is said to be so powerful as to project extra-psychic being external to the person who is in the condition of *himma*. *Himma* creates as real the figures of the imagination, but their reality is neither hallucinatory nor illusory; they are neither objectively nor subjectively real but belong to the intermediary and mediating realm of the *mundus imaginalis*.

The figures of the imaginal world are represented in the Islamic gnosis as the "eternal hexeities"[15] of man or his angelic "doubles." Angel is the archetype of each individual being, his "invisible master" and personal guide (*paredros*). In a theological context, angels are necessary whenever the Ultimate Reality is imagined as *deitas abscondita*, the hidden God or Godhead beyond human speech and thought. Like the Platonic *Eros* who spans the chasm between the Gods (the immortals) and men (the mortals), the Corbinian angels are the images of God's form; indeed they are God (*or* Gods) seen in such a form as an individual person is able to grasp. In his essay on "The Necessity of Angelology," Corbin draws attention to Deuteronomy 5:7, where it is written: "You shall have no other gods before my Face." Corbin connects this text with Neoplatonic angelology:

Introduction: Gnosis

Yes, but what is this Face? It could be a matter of that about which it is said: "You shall not see my Face, for no man sees me and lives" (Exodus 33.20). Yet, it is precisely a matter of the Face that God shows to man, his theophany, and the Angel of the Face, all the Angels of the Face, are his theophanies . . ., these theophanies of which the transformations correspond to the state and mode of being of those to whom they are shown, face to Face.[16]

The "secret," concludes Corbin, is "that the phrase 'You shall have no other Gods before my Face' comes to mean 'You shall have no other Gods before my Angel'."[17] David Miller has summarized Corbin's thought on angels in the following provocative passage.

So, the Angel as image of something transcendent here and now may be many things!—it is hermetic word . . ., herald, kērygma, guide, connecting link, eros, the Face of that which we face, heart and mind at one in imagination, alter-ego, a mediator . . . the immediacy of soul, the power and form of being itself, the gods, Self, God![18]

Angels, hopelessly sentimentalized in popular art—females in nighties tripping through the sky (as in Doré's illustrations of the *Divine Comedy*)—are in reality demons of might and terror prompting man to conform to their image. As the Sufi mystics repeatedly emphasize: "We are wrestling not *against* but *for* the Angel"—i.e., for our 'true' self, the archetypal image by which we are made. To know oneself is to know one's angel. According to the gnostic Book of the Contender, "he who has not known himself has known nothing, but he who has known himself has at the same time already achieved knowledge about the Depth of the All."[19]

Gnostic knowledge is the knowledge of the soul, and its aim is not to prove or to explain the soul but to transform it. In this sense, gnosis is an ancient name for depth psychology which

5

Introduction: Gnosis

Hillman identifies with psychology *tout court* and with psychotherapy: "I use the terms psychotherapy and psychology interchangeably, for a psychology that is not a depth psychology is inevitably superficial and off the mark, and a depth psychology is inevitably a psychotherapy."[20] The reason for Hillman's equation of psychology and depth psychology is that depth or the unconscious in archetypal psychology, instead of being a separate place cut off from conscious processes, is seen as identical with imagination. Our gnosis is, therefore, new to the extent that it leans toward aesthetics and perceives the depth of things in their "faces" (the phenomena) as they present themselves to imagination. Images—which, according to Jung himself, are the main content of "the unconscious"—do not hide anything inherently inaccessible to an attentive observer.

Furthermore, the soul in archetypal psychology is envisioned primarily, not in its individual or personalistic dimension, but macrocosmically—as the soul of the word (*anima mundi*): "The curative or salvational vision of archetypal psychology focuses upon the soul in the world which is also the soul of the world."[21] The gnostic soul has a decidedly non-human orientation: it does not belong to man; rather, man belongs to the soul or is in the soul.

Last but not least, archetypal psychology has consistently avoided substantiating the soul. The soul is not a substance, a thing, but a "perspective . . . a viewpoint toward things. . . ."[22] Hillman's strategy consists in "seeing through," which is the counterpart of Heidegger's method of destruction or deconstruction of Western metaphysics aiming at a new, and at the same time more original, experience of Being.[23] The Hillmanian "seeing through" is a psychological process of "deepening, interiorizing . . . the apparent," a "moving from the surface of visibilities to the less visible."[24] Hillman also insists that this process never stops because, as Heraclitus—whom archetypal psychology regards as the first depth psychologist of

6

the Western world—has said: "You could not discover the limits of the soul, even if you traveled every road to do so; such is the depth of its meaning" (Wheelwright, fr. 42). The soul has no (literal) beginning and no (literal) end; as Heidegger would say, it is simply "there" (the *Da* of *Sein*). Therefore, instead of trying to explain the psyche, Hillman prefers to complicate and compound—to "confirm the enigma"[25] and "to account for the unknown in the still more unknown, *ignotum per ignotius.*"[26] What this implies is that the soul is something that has to be made. We 'have' and we 'know' soul only on our way toward soul. Gnosis, like depth psychology, is soul-making.

Heidegger's thinking, like that of Hillman, is both a way and a vision, a way which is itself the seeing. "The way of thinking cannot be traced from somewhere to somewhere like a well-worn rut, nor does it at all exist as such in any place. Only when we walk it, and in no other fashion, only, that is, by thoughtful questioning, are we on the move on the way."[27] Naturally, therefore, Heidegger's path cannot be assimilated into any fixed and traditional category. True or "meditative thinking" does not result in firm conclusions on which the subsequent series of thoughts can be built without having to return to the beginnings. We are admonished to see not more but better—to see that which we already know and always did know but which has been obfuscated by our subjectivistic attitudes, by lack of attention. As in gnosis, knowing is inseparable from being.

It would be a mistake, however, to conclude from this that Heidegger is promoting a new brand of irrationalism. In "The Letter on Humanism," he observes that strictness and rigor of thought have nothing to do with technical and theoretical exactitude of terms: "To think 'counter to logic' does not mean to stick up for the illogical, but only means to think the *logos,* and its essence as it appeared in the early days of thought. . . ." In effect, " . . . irrationalism, as a renunciation of *ratio,* rules as unrecognized and undisputed master of that 'logic' which

believes it can avoid a consideration of the *logos* and of the essence of *ratio*, which is founded on the *logos*."[28] What Heidegger is saying is that behind Apollonian reason there is—as its twin brother—unconscious irrationality bent on subjugating all things to the ego's a priori prescriptions. He calls this attitude "sub-jectism" and sees it as belonging to the same level of thinking as objectivism. According to Kreeft, "'object-ivism' is really a concealed form of subjectivism: conceiving things as objects implies referring them to an ego-subject as *its* objects. It is the I which projects ob-jects (*ob-iacio*). Therefore transcending subjectivism is transcending objectivism as well."[29] Put differently, man as a subject derives the meaning of the world from himself and his own meaning from the extent to which he conquers the world. In Heidegger's opinion, this activity (or agitation) between subjects and objects is the source of Western nihilism, prophesied by Nietzsche: "Alas! there cometh the time when man will no longer launch the arrow of his longing beyond man—and the string of his bow will have unlearned to whizz!"[30]

In order to avoid the false dilemma of "sub-jectism" or subjectivism versus objectivism, Heidegger wants to think non-conceptually and non-systematically yet with rigor and strictness. In contrast with the verbal eccentricities characteristic of *Being and Time*, the language of his later writings is simple and poetic. It is as if Heidegger has recovered the speech of the soul in which, as Hillman says, "there is no necessary opposition between clarity and imagination, no need to believe . . . that deep ideas must be dim, while clearness is founded on shallowness." The later Heidegger no longer neglects the desire of soul "for a concrete and poetic precision about its imagining and emotion. . . . "[31] In his *Nietzsche* book, he refers to the "poeticizing essence of reason" (*das dichtende Wesen der Vernunft*): "before one thinks in the usual sense one must first poeticize."[32]

In an essay on Heidegger's *Wegmarken*, Thomas J. Sheehan bemoans "that scandal of all scandals: just what [is] Heidegger

8

talking about?"[33] The obvious answer would have to be that Heidegger is talking about Being. But that should be hardly scandalous to a professional philosopher. Rather, the "scandal of all scandals" has to do with the way in which Heidegger speaks about Being, that is, by cutting under the opposites of rationalism and irrationalism, subjectivism and objectivism, theory and praxis. A path such as this is difficult to follow for an outsider because the destination of the path can be surmised only as one goes along it. Heidegger's thinking is not about anything given in advance but about something which is, so to speak, pre-given and pre-understood—Being. In his own words, thinking is "the recollection of Being and nothing else. . . . Such thinking results in nothing. It has no effect. It suffices its own essence, in that it is. . . . For it lets Being—be."[34]

I have identified gnosis with "salvational knowledge" which, as it now turns out, "results in nothing" and "has no effect." There is no contradiction here if we realize that the verb "to save" (German *retten*) means basically to rid something of what impedes it from being itself, to set it free to be what it is. Salvation results in nothing for the simple reason that it is not something to be acquired and held as one's possession. It is not a thing (hence no-thing) but an event, an occurrence that takes place in the soul. To say "in the soul," however, does not mean that we escape from the world into soul. As we saw, the soul, in addition to being "my" soul, is also the soul of the world. "Salvational knowledge," therefore, is concerned with resouling the world as well. It is a recollection, a remembering of a worldly soul and of an ensouled world. So—what are we to do? Nothing. We have to let the soul be. We have to let the world be. We have to let Being—be.

I

Soul and World

1. Dasein, Being, Truth

The gnosis of Heidegger and Hillman is rooted in the desire to overcome dualism (inner versus outer, spiritual versus material, reality versus appearance) by recovering a level of awareness which is more original than sensation and perception, on the one hand, and ratiocination on the other. In Heidegger, there are several terms that point to this level: Dasein, Being, *Ereignis* (usually translated as Event of appropriation), *aletheia* ("truth"), the Foursome, *physis*. The corresponding key concepts (or rather symbols) in Hillman and archetypal psychology are soul or psyche and imagination. As there is no necessary logical sequence from one of these terms to another, any one of them could serve as a starting point. Considering, however, that there is a certain development in Heidegger from an ontocentric emphasis (I shall disregard altogether his early anthropocentric leanings) to a geocentrically oriented thinking, it is necessary to begin with a brief consideration of "Dasein" and "Being."[1] The other terms will be discussed more or less as the occasion arises.

The German word "Dasein" means "existence," "life," "presence" and expresses the concreteness of here and now. In Heidegger all these shades of meaning are retained but in a deepened way. A first misunderstanding to be avoided is that Dasein refers to man in a humanistic or anthropological sense.

Soul and World

According to the well-known *Being and Time* period definition, *"the 'essence' of Dasein lies in its existence."*[2] Another version says that "man occurs essentially in such a way that he is the 'there' [*das 'Da'*], that is, the lighting of Being."[3] As these quotations show, Heidegger assumes a structural similarity between Being and Dasein: to be means to be open, unhidden, and Dasein means to be the place of this openness and unconcealment. Accordingly, Dasein is not primarily man at all but the place of the presence and revelation of Being. The *Da* in Dasein is Being itself brought out of concealment into disclosure, which disclosure is also the truth (*aletheia*) of Being. Dasein is the "truth" of Being. Vincent Vycinas has put it as succinctly as possible: "Dasein is Being in its openness," or again, "the *Da* of Being is Dasein."[4]

The word "existence," as Heidegger understands it, points to the fact that man alone, in contrast to all other beings, is not a pure object like a rock on a beach but *has to be*. He is not a thing whose nature can be exhausted by stating its essence (the "what") but a creature for whom his own nature is at stake: his very essence lies in his possibilizing thrust toward the future, in being out toward possibilities which must be maintained as possibilities without ever becoming completely actualized. Heidegger rejects the Aristotelian definition of man as *zoon logon echon*, the rational animal or a composition of essence and existence (soul and body), for the mode of being of the *zoon* is modeled on that of a thing (i.e., of something objectively present, *vorhanden*), and the nature of *logos* is in no way clarified by merely appending it to the *zoon*. In sum, human existence is essentially ec-static or self-exceeding. Man is truly human when he stands in the openness of Being; he is the place where Being opens up and reveals itself.

The definition of man as the "truth" (openness) of Being is further qualified by Heidegger in terms of guardianship. Man is the guardian of the truth of Being; he is "not the master of be-

ings" but the "shepherd of Being."[5] Now one might say that the cardinal virtue of a shepherd is sustained attention to the flock. The shepherd is the "guardian angel," constantly on alert, watching, like the Hindu Purusha, and preventing us from self-absorption. The angel keeps us in openness to Being (the flock). In his essay entitled *What Is Called Thinking?*, Heidegger understands the Greek verb *noein* (usually translated as "to think") in the pre-Socratic sense of "to perceive" (*verhenmen*) or to be attentive to something. *Noein* means taking to mind and heart and keeping at heart. "What is taken to heart, however, is left to be exactly as it is."[6] It is also, says Heidegger, "what we understand by scenting—though we use the word mostly of animals, in nature."[7] I shall elaborate on this in Chapter III. For the moment let us simply say that there is animality in our angelicity. Dasein is an ex-static—not rational or blissful—animal whose essence is to watch so as to let things be just as they are.

But what about Being? The main difficulty in grasping what Heidegger means by "Being" is due to ambiguity inherent in its English usage. It is not always realized that as a participle it has at once the characteristics of verb and noun. As a noun it is a name for beings, things: a table is a being, etc. Anything that is, is a being. In this sense "being" is the most empty and abstract feature of anything. As a verb, however, "being" signifies the "to be" of things (*to einai, das Seiende, l'étant*). Heidegger's contention is that the whole history of Western thought has emphasized the noun-character of the word "being" and has forgotten the verb (the "to-be" of what is) dimension. In other words, there has been an excessive preoccupation with things (essences) as objects so much so that "Being" has been converted either into the Supreme Being (God), the *ens realissimum* of theology, or to "being in general" (common denominator of beings such as matter, energy, spirit, will, consciousness) of metaphysics. In both cases, i.e., in Western onto-theology, Being is modeled on the concept of an object-thing. Heidegger is

Soul and World

convinced that the Western pursuit of objectivism is really a
disguised form of subjectivism, for in the very act of conceiving
things as objects we refer them to an ego-subject as *its* objects.
The result of such a "plot" is that reality becomes only the sub-
ject's picture, his world-view. To Heidegger, Being is nothing
"entitative" and therefore it does not have an independent,
separate reality. Heidegger refuses to hypostatize Being, and his
program is neither metaphysical nor theological but phenom-
enological.

Being for Heidegger is not a vacuous concept standing for
something remote or abstract but the most concrete and closest
of presences. To perceive Being we must turn to sensible things.
In William Barrett's words, we are "immersed up to our necks,
and indeed over our heads [in Being]. . . . Our ordinary human
life moves within a preconceptual understanding of Being and it
is this . . . understanding of Being in which we live, move and
have our Being that Heidegger wants to get at as a
philosopher. . . ."[8] It is also for this reason that, in Heidegger's
opinion, the Cartesian formula *Cogito ergo sum* must be inverted
by first considering the Being of *sum* or the I. The primary
datum is not the *cogito* but the *sum* or the act of existing with the
world and having a world. Descartes locks up man in his skin-
encapsulated ego—an assumption which is as perverse as it is
gratuitous. Our so-called mental processes are ex-static, we are
essentially and from the beginning out-of-doors, in-the-world.

In a capital passage Heidegger explains:

> When Dasein directs itself towards something and grasps it, it
> does not somehow first get out of an inner sphere in which it has
> been . . . encapsulated, but its primary kind of Being is such that
> it is always "outside" alongside entities which it
> encounters. . . . And furthermore, the perceiving of what is
> known is not a process of returning with one's booty to the
> "cabinet" of consciousness after one has gone out and grasped it;
> even in perceiving, retaining and preserving, the Dasein which
> knows remains outside and it does so as Dasein. . . . a "com-

14

mercium" *of the subject with a world does not get* created *for the first time by knowing, nor does it* arise *from some way in which the world acts upon a subject. Knowing is a mode of Dasein founded upon Being-in-the-world.*[9]

Dasein's Being-in-the-world is a unitary phenomenon, a primary datum within which the question of whether the world exists apart from the knowing subject simply does not arise. "The 'scandal of philosophy' is not that this proof is yet to be given, but that *such proofs are expected and attempted again and again.*"[10] We may juxtapose to this Hillman's observation in his *Inter Views*: "Imagine," he says, "how much serious time is spent proving the reality of the external world. Imagine having to prove what every animal knows."[11]

Heidegger's phenomenological approach, to be discussed in more detail in Chapter II, is tersely expressed in these words: "Being means appearing. This does not say something supplemental, which befalls Being occasionally. Being 'essentiates' as appearing."[12] Heidegger is not advocating here a form of radical immanentism or a new version of pantheism. His point is simply that Being is not opposed to appearing; rather "appearing" is the lighting process by which beings are lit up. Ordinarily this manifestation of Being, this light or lighting (*Lichtung*), is easily forgotten because it is *everywhere*.[13] The word "everywhere" is useful inasmuch as it suggests that our inability to see the "light" is due to the fact that it is neither something objective nor subjective, neither inner nor outer, but a third that lies between and beyond such opposites; the light is an open domain (*Lichtung*) enabling the encounter between subject and object to come about. In the last resort, the light (Being) is *Da*-sein, and Da-sein is Being in its openness, the place where meaning originates, the "there" of meaning. As we shall see shortly, in archetypal psychology this place is called the soul—"that unknown component which makes meaning possible, turns events into experiences."[14]

15

Soul and World

In a nutshell and as a working hypothesis, I suggest the following formula: Dasein = Being = soul. It seems that Heidegger is saying as much in the following words.

> Why is it that we are ever and again so quick to forget the subjectivity that belongs to every objectivity? How does it happen that even when we do note that they belong together, we still try to explain each from the standpoint of the other. . . . Why is it that we stubbornly resist considering even once whether the belonging-together of subject and object does not arise from something that first imparts their nature to both the object and its objectivity, and the subject and its subjectivity, and hence is prior to the realm of their reciprocity?[15]

For a more adequate grasp of some of the implications contained in Heidegger's statement "Being 'essentiates' as appearing," we must turn to his treatment of Plato (the rationalist) whom he regards as the first thinker to have initiated the process of the oblivion of Being in the history of Western philosophy. The turning point is reached in Plato's allegory of the cave (Book VII of the *Republic*) where the world of things for the first time becomes something objective (*Gegenstand*, object) which we face as spectators. From that point on we begin to encounter things optically by means of their looks. It is also at this juncture that truth takes on the meaning of a static, atemporal presence (idea) separated from the beholder and finally is declared to consist in the correctness of vision, i.e., in the correspondence of seeing with the object of vision. Truth is now identified with correct seeing, and thinking becomes a matter of placing an idea before the mind's eye, i.e., the proper manipulation of ideas. In this spectatorial notion of knowledge and its object, man is portrayed as carrying images of things around in an inner psychic box to compare them occasionally with the things outside the box. Truth is now a predicate, not of reality, but of thought and speech. Ideas are said to be mainly "inside" us or,

as in Plato, they belong to a purely spiritual realm radically distinct from the world of sensory appearances. In Heidegger's words, "in Plato . . . appearance was declared to be mere appearance and thus degraded. At the same time being, as *idea*, was exalted to a suprasensory realm. A chasm . . . was created between the merely apparent essent here below and real being somewhere on high."[16]

In view of the above, the oblivion of Being would be essentially the oblivion of the *Da* (There) of Being, i.e., of the fact that "Being 'essentiates' as appearing" and that this essentification occurs neither "here below" nor "somewhere on high" but in *Dasein*—the mediating factor between the spiritual (Platonic Ideas) and the sensuous. Robert Romanyshyn is right on target when he says that "Western metaphysics . . . forgets that idea is the appearance, the aspect, the perspective of things . . . [and] presumes that . . . ideas [are] created apart from the world, and apart from the way things show themselves."[17] To anticipate a bit, Heidegger will never cease to insist, however, that the appearance or manifestation of things is inseparable from their simultaneous concealment. There is no presence without absence, no Being without a certain lack of being. Oblivion of Being, therefore, is not only the oblivion of the presence (the *Da*) of Being but also of the finite and temporal character of Being's essentification in appearing. As Zimmerman puts it, "beginning with Plato, metaphysics forgot about the intrinsic relation between Being and nothingness (temporality, finitude) and concentrated on interpreting Being as the 'ultimate foundation' of reality."[18]

It seems to me that Heidegger's correlation of Being and appearing may be made more palatable by relating it to a central insight found in Hermetic and alchemical tradition. A treatise of the twelfth century, attributed to the legendary Hermes Trismegistus, describes a conference of twenty-four philosophers at which the question is proposed: *Quid est Deus?* Among

the twenty-four different *sententiae* given in reply by the philosophers, the third is: *Deus est sphaera infinita, cuius centrum est ubique, circumferentia nusquam.*[19] Leaving aside the question of *Deus*, the expression *"centrum est ubique"* ("the center is everywhere") would refer, in the present context, to the light that is "everywhere." We forget this light because since Plato our attention is concentrated either on the real world of Ideas or on the illusory realm of sensible things. What constantly escapes us is the mediating function of light, its *Da* or the light as the soul of things. Fundamentally, the oblivion of Being has to do with misdirected attention. Awareness of Being can be recovered by re-directing attention to the center which is everywhere, i.e., by realizing that there are many centers and that Being is wholly and indiscriminately present in each one of them. Each center—every thing and being—is a potential source of meaning. As a result, Heidegger's sentence "Being 'essentiates' as appearing" can now be read "Being is everywhere"—not single but multiple, One yet many, infinite yet limited. Moreover, to say that Being is everywhere also means that Being is truth as the *Da*, the revelation of Being, and that the mission of man consists in nothing more spectacular than in responding to this revelation.

Heidegger's theory of truth is based on the Greek phenomenon of *aletheia* (Latin *manifestatio*), composed of two elements, the negative alpha privative and the root of the verb *letho* or *lanthano*, which means to escape notice, to be hidden.[20] Truth, contrary to what Plato thought, is not correctness of vision but the dynamic emergence of Being into the light of manifestness and a simultaneous persistence in hiddenness and concealment; it is a concomitant appearance and withdrawal from view. This means that, inasmuch as truth is unconcealment, it can be grasped only in relation to concealment. Revelation happens as obfuscation. As Heidegger has it, unconcealment is rooted in concealment, *aletheia* in *lethē*, as in a reservoir

upon which thinking can draw. In Caputo's words, "The *aletheia* process for Heidegger is a process of *a-lethē*, where the hyphen serves to bring out that the emergence and rising up of presence take place out of an ineradicable core of concealment, of *lethē*. . . . Concealment is inscribed in the heart of un-concealment."[21] The *lethē* in which *aletheia* rests can be also described in terms of the Tao as the reservoir, the inexhaustible Void giving birth to all forms in the phenomenal world: "'The *Tao* of heaven is empty and formless,' says the *Kuan-tzu*, and Lao Tzu uses several metaphors to illustrate this emptiness. He often compares the *Tao* to a hollow valley, or to a vessel which is forever empty and thus has the potential of containing an infinity of things."[22]

The point Heidegger wants to make by choosing the word *aletheia* is that the Greeks did not have a word for "truth" in the conventional (spectatorial) sense of the term. They had only the word *alethes* ('unhidden') meaning evident, manifest, open, present. The implications of this fact are momentous. It suggests that truth is "not poked away in some odd corner or other, or popping its head up at some unexpected and unusual juncture of events. . . . From the moment we opened our eyes a world was disclosed to us. . . . To be in a world—any world—is insofar-forth to be in the truth."[23] Truth and Being are inseparable in that they are given in every single act of ex-isting. Ex-istence means to be ex-posed to the things, to be placed outside the realm in which concealment rules. To exist is to be "there" or to-be-in-the-world and by the same token to be in truth. Most of the time, however, we are not in-the-world. We prefer to busy ourselves in asserting our identity against the world without realizing that this self-assertion, this search for identity, is nothing more glorious than a futile attempt to remain the same (*idem*) from moment to moment, day in, day out. We fail to see that we do not belong to ourselves but to Being, the world, the Soul and that our truth is in "being-in-the-soul."

Soul and World

2. Toward an Ensouled World

My aim in this part of the chapter is to show some of the ways in which Heidegger's gnomic utterances about Being, Dasein, etc., may be more adequately understood by relating them to such central notions of archetypal psychology as soul, imagination, and the Jungian *esse in anima*. I am not claiming that Heidegger can or should be reduced to Hillman. I merely intend to elucidate, as far as possible, the matter of thought under consideration (gnosis) by making Hillman and other archetypal psychologists say what Heidegger from his vantage point could not. I should like to begin with Hillman's statement that ideas are "both that which one sees—an appearance or shape in a concrete sense—and that by means of which one sees. We see them, and by means of them. Ideas are both the shape of events . . . and the modes that make possible our ability to see through events into their pattern."[24] Hillman also stresses that there is a constant temptation to hypostatize ideas into literal things: to see ideas rather than seeing by means of them. This, as we saw, is precisely what Heidegger means by forgetfulness of Being in the history of Western metaphysics: truth, expressed as an idea, has been converted into something to speculate about, a distinct and distant realm of self-subsisting entities essentially unrelated to the world of appearances.

Furthermore, if our ideas are also modes of seeing ("that by means of which one sees"), they are bound to change in accordance with our states of consciousness or, better, states of the soul. For as Plato said, notwithstanding Heidegger, idea is the "eye of the soul."[25] In Hillman's words, "the soul reveals itself in its ideas," and "we are always in the embrace of an idea."[26] Indeed, "we see what our ideas, governed by archetypes, allow us to see."[27]

But precisely what are these "eyes of the soul"? Are we doomed to relativism and solipsism, fated to see only what we

Soul and World

want to see? The answer to this question is foreshadowed in Plato's doctrine of *anima mundi* according to which soul had been diffused through the body of the world by the Demiurge, "wherefore, using the language of probabilities [i.e., the language of myth] we may say that the world became a living creature" (*Timaeus*, 30). From Plato onward, the concept recurs, with many variations, in the Stoic philosophers, in Plotinus, in Nicolas of Cusa, as well as among the Cambridge Platonists (More, Cudworth) and in the nature philosophy of the German Romantics.

In Hillman's psychology, the Platonic *anima mundi* is brought down to earth and particularized, though not in a pantheistic fashion. Earthly phenomena are elevated (or "reduced") to the level of soul, not soul to the level of earthly phenomena. The *anima mundi* is now:

> *that particular soul-spark, that seminal image, which offers itself through each thing in its visible form* . . . anima mundi indi-
> *cates the animated possibilities presented by each event as it is, its sensuous presentation as a face bespeaking its interior image. . . . soul is given with each thing. . . . All things show faces. . . . They announce themselves, bear witness to their presence: 'Look, here we are.' They regard us beyond how we may regard them. . . . This imaginative* claim on our attention [emphasis mine] *bespeaks a world ensouled.*[28]

In answer to our previous question, we can now say that the eyes of the soul (or the ideas) by means of which we see are the same eyes with which the world—and everything in the world—sees. The ideas are not only inside our heads but out there—in the world—as well. It is reported that Goethe could see ideas with his own eyes. What he saw was not so much Platonic or Kantian ideas, divorced from the *Ding an sich*, but the plant archetype (*Urpflanze*). He saw with the eyes of the soul an *Urphänomen* in the Botanical Garden of Padua.[29]

21

Soul and World

Anima mundi is the Platonic-Hillmanian counterpart of Heidegger's "world," a word which he uses interchangeably with "Being." "'World' . . . does not in any way signify . . . the earthly being in contrast to . . . the 'spiritual.' 'World' does not signify . . . a being at all and no realm of beings, but the openness of Being. Man . . . stands exposed to the openness . . . which is Being itself, that has projected the essence of man into 'care'. . . . Man is . . . in the openness of Being; this Open only clears the 'between,' within which the 'relation' between subject and object can 'be.'"[30]

Now it is nothing short of remarkable that Heidegger's idea of Being or the "World" projecting "the essence of man" is also encountered in myth and mythical thinking. The primitive, as Lévy-Bruhl, Henry Frankfort, and Cassirer have shown, lives in a magical world involving objects and beings in a network of mystical participations and exclusions. Contrary to the nineteenth-century anthropologists who held that early man fills an empty world with the ghosts of the dead, demons, spirits, etc., the prevalent view today is that the figures of myth are creations of a psychic energy, *mana* (Codrington), which is present in all things. *Mana* or psyche (*Seelenstoff*), as Jung puts it, is not "the epitome of all that is subjective and subject to the will . . . it is something objective, self-subsistent and living its own life."[31] According to Hillman, animation or personification has nothing to do with the projection of human feelings and emotions onto a detached and pre-existing nature. Rather, it is a spontaneous activity of the soul, a way of experiencing the world as "psychological field" or, in Heidegger's words, as "the openness of Being." "Just as we do not create our dreams, but they *happen* to us, so we do not invent the persons of myth and religion; they, too, happen to us. The persons present themselves as existing prior to any effort of ours to personify. *To mythic consciousness, the persons of the imagination are real.*"[32]

22

Soul and World

The question "who projects whom or what?" is wrongly posed because it assumes a dualistic standpoint. From the perspective of mythical thought as well as from that of archetypal psychology, projections are 'just so'; they simply happen as the soul itself happens. And the 'where' or the locus of this happening (Heidegger will call it *Ereignis*) is neither the I nor the nature but a common presence, the psyche. The psyche is the projector and the projected in one.

The same seems to be true to Heidegger's Being or, for that matter, Dasein. Da-sein is neither subject nor object, neither mind nor matter but the phenomenological equivalent of what Jung calls *esse in anima* conceived as a third reality between subject and object, mind and matter.[33] The Jungian "soul" is the Platonic *metaxy*—a principle of relationship or betweenness holding together heaven and earth and making them participate in each other. It is also Eros—the mighty daimon who, far from being a merely human attitude, is a metaphysical factor in all nature, the miracle in the center of being preserving the universe from dissolution into a deadly mass.

The *esse in anima*, like Da-sein, is self-exceeding; it infinitely surpasses man. Hillman has expressed the non-human nature of soul as follows: "Man exists in the midst of psyche. . . . Therefore, soul is not confined by man, and there is much of psyche that extends beyond the nature of man. The soul has inhuman reaches."[34] Heidegger, for his part, has articulated the epistemological problem of the relationship between subject and object by saying that the "*Dasein is the Being* of this 'Between.'"[35] As we saw a moment ago, man's essential nature (his ex-istence or his ec-static nature) consists in his relation to Being; he is, in a fundamental sense, non-human: "the question concerning man's nature is not a question about man."[36] In the very essence of man there is something fundamentally non-human. In a similar way, Hillman states that our essentially dif-

23

fering individualities are "really *not human at all*"[37] and that "soul-making means dehumanizing."[38]

We must now turn to what is probably the most crucial discovery of Jung: identification of the psyche and image—a discovery which I take to be psychologically equivalent to Heidegger's phenomenological statement that "Being 'essentiates' as appearing." According to Jung, "everything of which we are conscious is an image," and "image *is* psyche."[39] Archetypal psychologists have further elaborated on Jung's statement by stressing that images, like the soul itself, are self-generative, self-referential, and irreducible to anything other than themselves (for example, to perception and such offshoots of perception as memory and hallucination). It is also pointed out by the writers in the field that imaginative presentations are *simultaneous* in character: whatever we imagine is given all at once (*simul totum*), presents all of itself. According to Patricia Berry, simultaneity means that there is no priority in an image; all parts are co-relative and co-temporaneous. "Everything is occurring *while* everything else is occurring . . . simultaneously."[40] Images (especially in dreams) tend to disregard the linearity of day-light consciousness; there is no fixed order or hierarchy, no narrative, no before and after.[41]

The simultaneous nature of images means that they are true in Heidegger's sense of *aletheia*. Images are unconcealed in that they are pure presences beyond the split of subject and object. This again would indicate that within the realm of the psyche, appearance (phenomenon) and reality (noumenon) are identical. Edward Casey has observed, without explicit reference to Heidegger, that "imagining is . . . all appearance and nothing but appearance."[42] What is meant here by "appearance" is obviously not "illusion," for the latter always presupposes a true state of affairs against which it can be measured and eventually corrected. An imaginative experience, being self-referential, cannot be compared to anything extraneous to it; it is self-

explanatory, i.e., wholly contained in the mode of its appear-
ance. An image means exactly what it is and is what it means.
Put in more traditional terms, in an image there is no discrep-
ancy between form and content.

Nevertheless, it must be understood that the kind of truth we
experience in imagination is not only 'plain' (unhidden) but also
highly elusive, protean, devious; it is truth by innuendo rather
than *ex cathedra*. Imaginative truth is revealing-concealing or, to
use Hillman's recent expression, it is a "twisted truth,"[43] which,
like beauty, must not be perfect if it is to be enjoyed. Honoré de
Balzac has said that the artist is continuously at work on the
one masterpiece that is never created; if it should be accom-
plished, it could not be seen, for in the perfect image there is
nothing more to see.[44] Truth is not *adequatio intellectus et rei* but
a movement from concealment into revelation and back into
concealment, a movement that is patterned upon the cosmic
alternation of seasons, of day and night, light and darkness. Im-
aginal truth is essentially uroboric.

Finally there is the old dilemma of true versus false imagina-
tion (or fancy).[45] Casey has taken a decisive step toward solving
this dilemma by stating that an image is not what one sees but
the way in which one sees. Archetypal psychology supplements
this insight by using the criterion of response: metaphorical and
imaginative response to images is better than fanciful or literal
because the former deepens and complicates the image instead
of dissipating or eventually freezing it into an object that can be
manipulated by *ratio*.[46] I will have more to say on this in
Chapter II. Meanwhile I would like to place imagination within
a wider—cosmic—context so as to make it more definitively co-
terminous with the non-human dimension of the soul. In this I
am inclined to follow Blake who, instead of differentiating be-
tween kinds of imagining, declared that "The Imagination . . . is
the human Existence itself."[47] In Blake, imagination is an in-
clusive concept implying and containing within itself all the

other powers of cognition. Somewhat like in eighteenth- and nineteenth-century German Idealism (and in Coleridge), it is the central element not only in man but also in cosmic creation itself: the subjective pole of being and the objective pole of natural phenomena interpenetrate through imagination. As in Schelling's philosophy, spirit is invisible nature and nature is visible spirit, the concretion of spiritual imaginative force. Nature or matter is concrete spirit. What this means is that imagination presents nature in its highest sense, identical to the soul of man. Ultimately, therefore, the Delphic injunction "Know thyself" and the modern precept "Study nature" become the same maxim, for self-knowledge is nothing else than consciousness of the world (anima mundi) as perceived by the self. There is an agreement of ideas in the mind with the laws (ideas) in nature and of human imagination with the cosmic (or divine) imagination.

What we get here is a kind of universal ecology. Everything in the cosmos interconnects with its immediate surroundings, and these surroundings with wider environs, until the world, the solar system, and more are included. As Heidegger will later say, the world "worlds" and things "thing." Things necessarily exist through and by other things, and there is no isolated Being or "thing-in-itself." The whole of nature works through each thing, and each thing is a reflection of the whole. But again, as Hillman insists, this is not "fuzzy pantheism" or a "general adoration of nature." Rather, the whole of nature is experienced, as in Blake, through "that joyful scrutiny of detail, that intimacy of each with each such as lovers know."[48]

II

From Phenomenology to Angelology

1. Phenomena, Images, Angels

Our previous discussion may be summed up by saying that Heidegger's "oblivion of Being" is closely related to the neglect of the psyche as a place of being (*esse in anima*) and the distrust of imagination in Western thought. "Imagination" (and its cognates) is never used by Heidegger in a cosmological sense (as 'the poetic basis of the cosmos') or as a fundamental power of the soul underlying all other faculties and enabling us to see into the inner life of things.[1] The reason for Heidegger's refusal to deal *ex professo* with the question of imagination is twofold: first, he rejected the classical distinction of the faculties of intellect, sense, and imagination; second, imagination, as the word is used in the traditional aesthetics (as, for example, when it is said that poetry is a product of imagination), is something purely subjective, a subjective achievement.[2] Subjectivism, in Heidegger's view, is the bane of Western metaphysics from Plato to Descartes. Naturally, therefore, his leap out of the metaphysical tradition compels him to avoid terms coined by that tradition. This is far from saying that Heidegger ignores the problems which lie hidden under such concepts as sensation, imagination, etc. On the contrary, I would make bold to suggest that Heidegger, unbeknownst to himself, is engaged in what Hillman calls "imaginal reduction."[3]

From Phenomenology to Angelology

"Imaginal reduction" is an attempt to demonstrate, by evocation and description, that images are the basic givens of all psychic life and that we can point to the non-human stratum in man (the no-thing at the center of our being) only by moving through the poetic mode and by using poetic tools. Imaginal reduction is also "archetypal hermeneutics"[4] based on the metaphor of depth and propelled, as if by inner necessity, into infinite regress; it only stops (for a while) at the reality of the psyche which is itself the ultimate provocation never to stop. In Heidegger's case we are going to witness a development (or a regress, if you like) from ontology to phenomenology. Since, however, his notion of the phenomenon is in most respects similar to what in archetypal psychology is meant by "image" and, furthermore, since images are angelic in the sense we are using this term, it will be necessary to conclude that Heidegger's phenomenology demands completion in angelology.

Phenomenology, for Heidegger, is primarily a method whose motto is "to the things themselves." We get to the things themselves not by legislating the conditions under which they are allowed to appear but by letting "that which shows itself be seen from itself in the very way in which it shows itself."[5] Typically, Heidegger begins with the word "phenomenology" itself which is derived from two Greek terms, *phainomenon* and *logos*. *Phainomenon* is not identical with "appearance" in the usual sense; rather, it signifies the actual showing itself of something (from the verb *phainestai* 'show oneself'). In the original Greek setting, a phenomenon cannot be separated from the thing itself. In Heidegger's view, the becoming-manifest of the phenomenon takes place through the activity, indeed through the being of the phenomenon itself; it shows itself through itself, it makes itself understood through its own being, its just-so-isness. Incidentally, it is for this reason that science, according to Heidegger, "does not think,"[6] for it never allows the object to be

From Phenomenology to Angelology

what it is and prefers to manipulate it. The basic meaning of logos is 'speech' and only derivatively 'reason,' 'judgment,' 'ground,' etc. *Logos* as speech means rendering manifest the thing spoken about (*apophansis*, 'letting something be seen'). The truth of *logos*, its *aletheia*, consists in taking out into the open that which is spoken about. Truth is dis-covery, re-cognition. As Mehta explains: "In the Greek sense, truth resides basically in *aesthesis*, the pure sensible taking in or perception of something (*vernehmen*). 'True' in the purest and more original sense, that of discovery, is the pure *noein*, the straightforward perceptual awareness of the simplest sense qualities. . . . Such awareness can neither mask itself nor be false, but at the most remain uncognized."[7] If we now put the two words *phainomenon* and *logos* together, what we get is a unified notion of "letting something show itself as it actually is." Thus phenomenology is only a method, indeed a therapy of *letting* us see things themselves in their very Being.

Heidegger's concept of phenomenology implies a radical reversal of our habitual subjectivistic *and* scientific way of thinking: it is not we who "objectively" decide what things are; things themselves speak and show themselves if they are let be in their own manner of being. Vycinas characterizes the phenomenological attitude as a "respectful stand in face of reality which allows this reality to appear in its own way. We do not dictate reality, reality dictates us."[8]

Palmer, commenting on Heidegger's phenomenology, warns the reader that it should not be understood as "some primitive animism." Rather, Heidegger is saying that "the very essence of true understanding is that of being led by the power of the thing. . . . Phenomenology is a means of being led by the phenomenon. . . ."[9] In our estimation, "the power of the thing" is nothing more occult than the soul or the Being of a thing. On one occasion Heidegger does not hesitate to identify *mana*—the

soul-stuff of the mythical thought—with Being: "Mana [is] not . . . a being among other beings but . . . the 'how' of all the mythical real, i.e., the Being of beings."[10]

The upshot of the above considerations, from the point of view of archetypal psychology, is that phenomenology begins "in a world of ensouled phenomena,"[11] i.e., on an imaginal level. Corbin expresses the same by saying that "with the help of phenomenology, we are able to examine the way in which man experiences his relationship to the world without reducing the objective data of this experience to data of sense perception or limiting the field of true and meaningful knowledge to the mere operations of the rational understanding."[12]

The Heideggerian phenomenology paves the way for gnosis by producing the kind of knowing which is not divorced from being. In this sense phenomenology *is* gnosis—a knowledge that is effectuated in the soul and by the soul. The soul, in Jung as well as in archetypal psychology, is not a copy of the world but an autochthonous reality, the angel who has no biography imprinted upon its 'unconscious' by outer circumstances. The soul has no specific message to be delivered to the outside world. The soul is the world and the message.[13] It is a *phainomenon* that resonates by itself and of itself. The soul is image and imagining. Images or subtle bodies "do not reflect a borrowed light . . . [they] have their own hardness, their own innate gleam and ring. They are not reflections of the world but the light by which we see the world."[14] Images are angels who *are* the message—from which we conclude or, rather, 'leap' to the conclusion that phenomenology is angelology. In effect, we have leaped into the famous hermeneutical circle.

Technically, the expression "hermeneutical circle" points to the interdependence of the knower and the known; what is to be understood must already (preconceptually) be known. For example, we understand the meaning of an individual word by seeing it in reference to the whole of the sentence, and,

reciprocally, the sentence's meaning as a whole depends on the meaning of individual words. Understanding is always (probably even in science, as Heisenberg's principle and field theory show) a circular or referential operation. As logic cannot fully account for the workings of this circle, a kind of leap into the hermeneutical circle becomes necessary, and we come to understand the whole and the parts together.[15]

Heidegger, as usual, goes to the radical sense of the term *hermēneuein* which, he maintains, bears profound affinity with the wing-footed messenger-God Hermes. Hermes brings fateful tidings from the divine; he is a go-between from Gods to men, the interpreter. To Heidegger, hermeneutics has to do not with historical methods of interpretation as against scientific methods but with the event of understanding as such. He sees philosophy itself as interpretation. Hermes

> brings the message of destiny; hermēneuein is that laying-open
> of something [exposition] which brings a message. . . . Such "lay-
> ing open" becomes a "laying out" [interpretation] explaining of
> that which was already said through the poets, who themselves,
> according to Socrates in Plato's dialogue the Ion (534e), are
> "messengers of the gods", hermēnēs eisin tōn theōn.[16]

Hillman speaks of "our archetypal hermeneutics" by which he means the study of soul:

> To study soul, we must go deep; when we go deep, soul becomes
> involved. The metaphors that we believe we choose for describing
> archetypal processes and ideas are inherently part of those very
> processes and ideas themselves. . . . there is an archetypal selec-
> tive factor involved in the invention of terms. . . . To lead mean-
> ings out of language . . . suggests that the meaning is already
> there.[17]

There are, however, other passages in Hillman's opus in which he discards the adjective "hermeneutic" in favor of "imagistic." I shall discuss this important change in a moment. For now, we

From Phenomenology to Angelology

must explore some of the implications of the circle, hermeneutic or not.

It is important to recognize that the kind of knowing gained within the circle has nothing to do with Cartesian certainty, wholeness, or the like. There are no specific or practical results that would ensue from circling. Rather, one is transported into "a more problematic and dynamic experience: the concealing/unconcealing, truth/error process of being."[18] The reason for this polemical state of affairs is that the circle of Dasein is endless in the Heraclitean sense of depth (*bathun*). There are no limits to the soul's circulation, no actualization of darkness into light, or error into truth. There is no final healing vision (as, for example, in Hegel), no finality of any kind except the finality of infinitude. The road (*hodos*) which the soul travels, according to Heraclitus, is an up-and-down way where up and down, like the beginning (*archē*) and the end (*pera*), are the same (fr. 60 and 103, *DK*). The Heraclitean "end" is not a simple or literal return to the same (a dull round) nor a unilinear messianic utopia. Miller describes it as "a depth, a peri-meter broken through like a horizon exploded. The deep 'end' is ultimately soul which is without end."[19]

Miller's sentence refers, of course, to the circle of Hermes Trismegistus whose center is 'everywhere'; it is, as we observed earlier, what Heidegger means by Being. We may conclude, therefore, that the leap, referred to by Heidegger, must be a leap into this vaster circle—a circle which is circumscribed by the uroboric course of the *anima mundi*. There are hosts of angels on this course. But, as we know, angels are far from being harmless or benign: "*ein jeder Engel ist schrecklich*" ("Every angel's terrifying"), says Rilke.[20] Angels are 'terrible' because, in Miller's words, their way is "to let go of things. . . . The letting-go involves one in a giving up of grasping from a perspective of ego ('I,' 'me,' 'mine')."[21] We are urged to "let go of things" for the purpose of a re-orientation from the ego-perspective toward an

From Phenomenology to Angelology

imaginal view of things, from the human *anima* toward *anima mundi*, from man to Being, that is also a move toward "imagination, a great beast, a subtle body . . . an *anima mundi*, both diaphanous and passionate, unerring in its patterns and in all ways necessary, the necessary angel that makes brute necessity angelic."[22]

The Heideggerian version of Husserl's call back "to the things themselves," supplemented by Jung, Hillman, and Miller, can now be summarized as follows. Being as a phenomenon is intelligible in that it is always pre-understood (non-conceptually) just like the psyche always understands itself in its images. If, however, we are to avoid the vicious repetition involved in psyche's circling, it is imperative to make circling somehow 'angelic.' Circling must take place on the imaginal level proceeding to an ever greater depth and revealing not *what* things are but *how* they are. The 'how-ness' of things is their phenomenality and their imaginational physiognomy, that is, their angelicity. By all accounts, this is bound to be a terrifying discovery requiring radical displacement of priorities. The ontological *prius* now becomes *esse in anima* (Dasein, Being)—an *esse* which is its own justification and which Heidegger will call Event of Appropriation or simply Play.

2. Phenomenal Archetype

Jung formulated his ontology in terms of *esse in anima*. His intention was to save the phenomena by identifying soul and image. Images had to be considered now "as full realities, not mere fantasies, mere hallucinations, mere projections—not anything 'mere' at all."[23] Jung's most explicit statement portending this radically new orientation reads: "Image and meaning are identical; and as the first takes shape, so the latter becomes clear. Actually, the pattern needs no interpretation: it portrays its

own meaning."[24] Jung is, in effect, saying that the archetypes of the unconscious—"the pattern"—should not be construed as the primary carriers of meaning. Archetypes in themselves are purely formal structures without specific content of their own; they acquire content (meaning) only in the course of an individual life, that is, through imagination.[25] The meaning of life is not something preestablished or to be found in life but given with life itself, with images that *are* life itself.

Following Jung's lead, archetypal psychology stresses the phenomenal aspect of archetypes, i.e., the identity of image and meaning. Instead of asking how archetype and image are related (as two distinct events), one begins with and concentrates on images in all their multiple implications. The adjective "archetypal" stands, not for an unknowable and noumenal content *in* the unconscious, but rather for the unfathomable and polymorphous nature of the images themselves:

> By "archetype" I can only refer to the phenomenal archetype, that which manifests itself in images. The noumenal archetype per se cannot by definition be presented so that nothing whatsoever can be posited of it. In fact whatever one does say about the archetype per se is a conjecture already governed by an archetypal image. This means that archetypal image precedes and determines the metaphysical hypothesis of a noumenal archetype. So, let us apply Occam's razor to Kant's noumenon. By stripping away this unnecessary theoretical encumbrance to Jung's notion of archetype we restore full value to the archetype image.[26]

Hillman also rejects the term "unconscious" insofar as it has come to obscure the imaginal. In archetypal psychology, the Jungian unconscious is no longer seen as a container filled with unknowable archetypes but as a tool for deepening and interiorizing the psychic imagery. "Recognition of the 'reality of the unconscious' is a re-cognition of the depth, fullness, richness of psyche, that it has contents, that it is not a *tabula rasa*."[27]

From Phenomenology to Angelology

Hillman has further clarified Jung's identification of image and meaning by distinguishing between the meaning of an image and its significance. A meaning is something subjective, given by us to the image; significance is what the image "gives to us"; it is a "gift of significance . . . fecund with implications. . . . The archetype's inherence in the image gives body to the image, the fecundity of carrying and giving birth to insights. The more we articulate its shape, the less we need interpret."[28] Meaning is in the shape of images (things) or, as Heidegger would say, in their appearances, in their phenomenality. Hermeneutics, therefore, becomes superfluous and is replaced by imagination.

> To see the archetypal in an image is . . . not a hermeneutic move. . . . Hermeneutic amplifications in search of meaning take us elsewhere, across cultures, looking for resemblances which neglect the specifics of the actual image. Our move, which keeps archetypal significance limited within the actually presented image, also keeps meanings always precisely embodied. No longer would there be images without meaning and meaning without images. The neurotic condition that Jung so often referred to as "loss of meaning" would be understood as "loss of image". . . .[29]

Heidegger's great innovation was to transform Husserl's call to return to the things themselves into an invitation to explore the pre-conceptual togetherness of man and world. His name for this togetherness or co-inherence is Dasein. Archetypal psychology, for its part, attempts to dig even deeper by going back to the mythical beginnings of the Heideggerian a priori in the imaginal psyche. The phenomenological slogan now reads: back to the images themselves (or, if one prefers the angelological mode, back to the angels themselves!). For, as we shall find in the course of this inquiry, things, in their pre-reflective givenness, are never mere things but rather images or, better, imaginal bodies. Things are animated, not because we make them

so by means of some anthropomorphizing magic, but because they are members in the body of that great animal (*anima mundi*) that to the early Greeks was the world of nature.

Hillman's attitude toward phenomenology is best understood in terms of what he calls "archetypal epistēmē" or "archetypal reversion." Archetypal epistēmē is a psychological method which dismantles metaphysics by relativizing the pivotal points of its traditional edifice: "pure reason" (Kant), "pure Being" (Hegel), "pure logic" (Husserl), "pure prehension" (Whitehead). One proceeds by methodically suspecting that any purity is too pure (too abstract) to be true. This relativization is necessary because all rational knowledge, all our objective and universal ideas are rooted in psychic reality. As Jung has it, "between the unknown essences or spirit and matter stands the reality of the psychic—the psychic reality, the only reality we can experience immediately."[30]

Extrapolating on Jung, Hillman submits that all knowledge must be examined in terms of archetypal images: the archetypal position "suggests nothing less than an archetypal *epistēmē*, an archetypal theory of knowing."[31] The relativization of reason, however, does not result in psychologism. Hillman avoids psychologization—converting all things into psychology in a narrow humanistic sense—by insisting on the transpersonal, transsubjective character of archetypes. In Miller's words, archetypes are not "subjective dimensions of mankind projected outward onto mythical names and stories" but "Gods," i.e., "worlds of being and meaning in which my personal life participates."[32] The Gods of polytheism are archetypal structures of a psyche that is by no means identical with man but, as Hillman says, "displays itself throughout all being. . . . The world is as much the home of soul as is my breast and its emotions."[33]

Hillman considers his work phenomenological inasmuch as he too turns to things and events themselves in order to "let them tell us what they are." He also shares the phenomenologist's "search for the essence of what is going on." However,

36

From Phenomenology to Angelology

Hillman distinguishes the psychological 'what' from the essentialist tradition (the quiddities of Aristotle) as well as from the phenomenological search for essences. The difficulty with the phenomenological standpoint is that it "stops short in its examination of consciousness, failing to realize that the essence of consciousness is fantasy images."[34]

The priority of fantasy, carried through to its full implications, means that phenomenological reduction becomes imaginal reduction or an archetypal reversion—a return to mythical patterns and persons of the psyche. The psychological 'what' is transformed into 'who' leading to the realization that there are Gods in our ideas.[35] Archetypal reversion implies that fantasy images are the fundamental facts of human existence. For it is from the stuff of these *numina* that we create our world, our reality. In the beginning is *poiesis*—the making of soul through imagination and metaphor. "First imagination then perception; first fantasy then reality. . . . Man is primarily an imagemaker and our psychic substance consists of images. . . . We are indeed such stuff as dreams are made on."[36]

The basic function of the imaginal Gods (Heidegger's prereflective understanding) is to provide cosmic perspectives for the soul enabling us to discover a sense of depth beyond the merely personal. At one point Hillman calls this deepening process an appeal to "the hidden God (*deus absconditus*), who appears only in concealment."[37] I shall take up the notion of the hidden God in the concluding chapter.

Paul Ricoeur has observed that Heidegger's hermeneutic phenomenology represents a "second Copernican reversal" in that the question asked by classical epistemology—"How do we know?"—is inverted by asking "What is the mode of that being who exists through understanding?" Heidegger inverts the theory of knowledge "by a questioning which . . . depends upon the manner in which a being encounters being, even before it opposes itself to it as an object in face of a subject."[38] The meaning of Ricoeur's words is clear: hermeneutic phenomenology

begins with the recognition that ontology, the inquiry into the "being" of things, must be tied to an analysis of man, the being who is engaged in that inquiry. There is no presuppositionless, objective, or simply reproductive understanding. In Gadamer's words, all our seeing is guided by "the excess of fantasy."[39] As I pointed out earlier, in terms of archetypal psychology this means that we never transcend the subjective premises in the psyche and that all our knowledge ultimately refers to the Gods who dwell in our ideas. To put it differently: just as hermeneutic phenomenology can be considered as an attempt to question and interpret itself, so the soul in archetypal psychology is "less an object of knowledge than it is a way of knowing the object, a way of knowing knowledge itself."[40]

I should like to maintain, however, archetypal psychology takes a step beyond Heidegger's "second Copernican reversal" by examining not only "the manner in which being encounters being" but also the ideas themselves by which being is encountered. In other words, the Heideggerian inquiry into the mode of being (Dasein) who asks questions is circumvented by replacing the epistemological question "How do we know?" with the question "*Who* knows?" By a short cut, as it were, Hillman dissolves the Aristotelian and the Kantian categories into divine imaginal forms and mythical figures (angels) providing an entirely new and at the same time very ancient a priori—"the a priori structures within the caverns and dens of the immeasurable imagination." The Gods (or angels) of mythology and psychology are now "personified universals"[41] enabling us to gain distance from the literalistic entrapments of language. By seeing ideas in terms of archetypal images, "psyche becomes more clearly separated from its literal identifications, making clearer the mirror by which life is reflected."[42] What is this mirror? Heidegger's answer will be that it is the mirror-play of the Foursome implicating earth and sky, Gods and mortals in the round dance of mutual appropriation (Chapters IV and V).

III

Thought of the Heart

1. "Thinking"

Thinking in the Western philosophical tradition is for the most part identified with reasoning and argumentative rigor. Doing philosophy, especially among the logical analysts, means to be engaged in a competition between arguments. In this capacity thinking is usually distinguished from what is assumed to be its less respectable, if not irresponsible, alternatives: mysticism, art, myth-making, poetry. To Heidegger, philosophy, based on this type of confrontationalist thinking, though useful and necessary in many respects, is rooted in "the technical interpretation of thinking"[1] which reduces beings to objects for the subject. Subjectivism, irrespective of its metaphysical orientation, takes man as the ultimate reference point or as the measure of all things. It recognizes no goal or meaning that is not grounded in rational certainty, and its modus operandi is what Heidegger calls "calculative thinking"—a thinking that plans and investigates, computes and never stops, never collects itself. Today it expresses itself in the frenzy of technological mastery and in the will to power involving man in the circle of its own projected world.[2] It is as Wallace Stevens has said: "We have grown weary of the man that thinks. He thinks and it is not true."

Heidegger seeks to overcome calculative (or representational) thinking not in order to eliminate thought and even less to

substitute feeling for thinking but to engage in a "more radical, stricter thinking, a thinking that is part and parcel of being."[3] His most commonly used expression to designate this gnostic engagement is "meditative thinking," whose basic feature is openness and receptivity to what is given. To understand what is involved in such an attitude, we must go back to Heidegger's earlier statements about the nature of Dasein. Dasein, it was said, is essentially self-exceeding, which means that man is related immediately and directly to Being; in effect, he *is* this relation and nothing more. To comprehend man, therefore, one must transcend the specifically and merely human, the subjective. We must "behold man's nature without looking at man."[4] Heidegger develops this claim by considering what is implied in the word "waiting." Normally, waiting pertains to human desires, goals, needs; we wait *for* something that interests us or can be advantageous to us. But there is also a sense in which we can wait without knowing for what we wait. In this kind of waiting, which may be called "waiting upon," we leave open what we are waiting for.[5] Waiting in the first sense is related to calculative thinking, whereas waiting in the second sense, referring as it does beyond the human, is analogous to meditative thinking. Gray characterizes the latter by saying that "the call of thought is to be attentive to things as they are, to let them be as they are and to think them and ourselves together."[6]

In his essay on Parmenides' saying "For the same is both to think and to be" (fr. 5), Heidegger further explains what is meant by thinking. According to the traditional interpretation, Parmenides is expressing a kind of rationalism, saying that being belongs to thought: the thinking of the subject determines what being is. Heidegger rejects this interpretation as thoroughly un-Greek and attempts to show that Parmenides meant just the opposite: thought belongs to beings. For the *to auto* ('the same') conveys, not the sense of uniformity or numerical unity, but rather the correlation of things that are mutually opposed. We

have to do here with the unity of different elements, which are held apart and kept together by the difference itself: "'The same' is the belonging-together of the different . . . through the different. We can speak of the same only when we think the difference. . . ."[7] Thinking and being are not identical: "They are precisely what is different. . . . But it is just in their difference that they do belong together. Where and how? What is the element in which they belong together? . . . Is it . . . a third thing which in truth is the first for both—the first not as their synthesis, but still more primary and more originary than any thesis?"[8]

Heidegger then goes on to trace the word "thought" to the Old English noun *thanc* which is derived from the closely related verbs *thencan* 'to think' and *thancian* 'to thank.' *Thanc* means 'a grateful thought,' and today it survives in the plural *thanks*. Thinking is a kind of thanking. "The root . . . says: the gathered, all-gathering thinking that recalls."[9] Initially, however, memory did not at all mean the power to recall. Rather, "the word designates the . . . concentration upon the things that essentially speak to us in every thoughtful meditation. Originally, 'memory' means as much as devotion: a constant concentrated abiding with something. . . ."[10] Thinking, therefore, in the sense of *thanc* means "man's inmost mind, the heart, the heart's core, that innermost essence of man which reaches outward most fully and to the outermost limits, and so decisively that, rightly considered, the idea of an inner and an outer world does not arise."[11]

What we have here is one of Heidegger's most explicit statements pointing to the close connection between meditative thinking and soul. In effect, a few pages later, having translated the Latin word *animus* as 'soul,' Heideggers adds that the "'soul' in this case means not the principle of life, but that in which the spirit has its being, the spirit of the spirit, Meister Eckhart's 'spark' of the soul."[12]

41

Thought of the Heart

Eckhart's "spark of the soul," however, should not be identified without remainder with meditative thinking. The ultimate source of thought for Heidegger lies not in something spiritual but in the Greek word *noein* to which we alluded earlier. *Noein* cannot be simply translated 'to think'; rather, it means 'to perceive' (*vernehmen*). Perceiving is not an activity of the subject legislating what can be rightfully considered an object, for in the pre-Socratic thought, i.e., before the distinction between subject and object was made, 'to perceive' and 'to be' constitute an original unity which is the presupposition for any subject-object distinction at all.

The pre-Socratic and Heideggerian *noein* (*nous*) expresses an attitude of attention to something: it is not a faculty that belongs to man or an immaterial activity of the spirit in virtue of which man is different from lower animals but a process by which Dasein first comes into its own as a human being. To be a human being is to be attentive. The Greek *nous* in this sense signifies not only the "minding" taken to heart but also "what we understand by scenting—though we use the word mostly of animals, in nature."[13]

In a bold move, Heidegger has effected a complete reversal of the traditional terms. The Platonic *nous* is brought down to earth, not however in the Aristotelian fashion by making matter the necessary locus of spirit, but by anchoring both matter and spirit in a "third thing" which is more primary than anything spiritual or material. The third thing is "scenting"—something pertaining to animals and at the same time peculiarly and exclusively human, for "man's scenting is divination . . . the mode in which essentials come to us and so come to mind, in order that we may keep them in mind."[14]

Essentials, the essences of things, come to us through scenting. This means that the quiddities of the essentialist philosophy are transformed into faces ("Who") we can recognize

because they are homologous with our own faces. The former insight that "Being 'essentiates' as appearing" is retained, but it is now supplemented by the need for attention. The essences of phenomena, their imaginal essences, only appear when we pay attention to them, when we take them to heart, which taking to heart is inseparable from letting them be just as they are.

Needleman, discussing the Ignatian (Loyola) term *sentire*, observes that it has little, if anything, to do with ordinary feeling or ordinary knowing or mystical ecstasy. "The point seems to be that something has to be awakened in man that is both highly individual yet at the same time free from mere subjectivity, something both my own yet free from ego."[15] Needleman calls this something "the intermediate." The intermediate is not the empirical man: it is not the ordinary mind or reason, not the ordinary emotions, not the personal. The terms that are best suited to convey what is meant here are: openness, sensitivity, presence, attention, seeing. "Openness," writes Father Sylvan, the alter ego of Needleman, is "purity of attention."[16] In the last resort, it is the power or function that defines the real nature of the soul: "The principal power of the soul . . . is a gathered attention that is directed simultaneously toward the Spirit and the body. This is 'attention of the heart.'"[17]

In his Eranos lecture entitled "The Thought of the Heart," Hillman states that "the heart's work is imaginational thought" or "imaginational intelligence."[18] No tour de force is needed to realize that what Hillman means by this expression is the same as Heidegger's "meditative thinking." Referring to Corbin's *himma*, Hillman elaborates: "The heart's characteristic action is not feeling, but sight. . . . The heart is not so much the place of personal feeling as it is the place of true imagining, the *vera imaginatio* that reflects the imaginal world in the microcosmic world of the heart."[19] In the common religious piety, the heart has become a sentimentalized and prettified version of the ego.

Thought of the Heart

We have forgotten that the heart is a microcosmic power, a microcosm that corresponds to and resonates with the macrocosm of the *mundus imaginalis*.

2. *Animal Gnosis*

Hillman's project, particularly in his later writings, is to return the heart to the world. He accomplishes this through a new and more imaginative reading of the Greek word *aisthesis*. In ancient Greek physiology, the root meaning of *aisthesis* has to do with breathing in or taking in of the world. As if paraphrasing Heidegger's "Being 'essentiates' as appearing," Hillman says that for the Greeks "the being of a thing is revealed in the display of its *Bild* (image)."[20] Beauty lies in the shining radiance of things, and the Greek as well as the Neoplatonic cosmos, in contrast to the Latin universe (from *unus verto* 'turning around one point'), is the manifest *anima mundi*. "Beauty is simply manifestation, the display of phenomena, the *appearance* of the *anima mundi*."[21]

What Hillman means by *aisthesis* and aesthetic response is "closer to an animal sense of the world—a nose for the displayed intelligibility of things, their sound, smell, shape, speaking to and through our heart's reactions, responding to the looks and language, tones and gestures of the things we move among."[22] For Hillman, ontology is in the nose, and phenomenology becomes *via aesthetica*.

But what of angels? They too are right here—before our animal noses. To a question of an imaginary professor who wonders whether Hillman is identifying instincts with images, the latter replies by evoking a breathtaking panorama of interlocking, dancing thoughts. This is it, he says, in effect:

> *Images as instincts, perceived instinctually; the image, a subtle animal; the imagination, a great beast, a subtle body, with*

*ourselves inseparably lodged in its belly; imagination, an animal
mundi and an anima mundi, both diaphanous and passionate,
unerring in its patterns and in all ways necessary, the necessary
angel that makes brute necessity angelic; imagination, a moving
heaven of theriomorphic Gods in bestial constellations, stirring
without external stimulation within our animal sense as it images
its life in our world.*[23]

Hillman's angels, in contrast to the noselessness of the
modern technological man, are endowed with real *imaginal*
noses. Their knowing is free from the constrictions of subjec-
tivism, because it is always accompanied by "gathered
attention" to what shows itself by itself and as it is in itself.
Aesthetic response to things and events demands attentive
noticing. We must resurrect, says Hillman, the old idea of *notitia*
as "a primary activity of the soul."

> *To notice each event would limit our appetite for events, and this
> very slowing down of consumption would affect inflation, hyper-
> growth, the manic defenses and expansionism of the civilization.
> [For] events speed up in proportion to their not being ap-
> preciated . . . events grow to cataclysmic size and intensity in pro-
> portion to their not being noticed.*[24]

Common to both Hillman and Heidegger is the determina-
tion to transfer the source of thinking from the Cartesian *cogito*
to extra-human locations. We must learn to see as animals see.
Corbin has observed that "certain of our traditions . . . men-
tion that animals *see* things which, among human beings, can
be seen only by the visionary mystics. It is possible that this vi-
sion takes place in the absolute *mundus archetypus*. . . . God
alone knows how it is!"[25] Hillman prefers to speak of "animal
faith" (Santayana). "The dog who sniffs the wind doesn't
believe in the wind: he simply tries to pick up on it and get what
it is saying. Not so simple, by the way."[26] "The cat jumps on the

45

tree and starts climbing. . . . The cat has an *animal* faith in the tree and it loves the tree, loves itself, loves jumping and climbing— . . . no introspection about belief."[27] Animal faith is not so simple because it demands a certain submission to "the gaze of things." The aesthetic response is not merely something subjective; the world too acts aesthetically upon us. We ourselves, as subjects, are "subjected to the gaze of things, ourselves a display. To the ensouled world we too are objects of *aisthesis*, aesthetically breathed in by the *anima mundi*, perceived by her, perhaps, even, aesthetically breathed out as images by an ardent *himma* in the heart of each thing."[28]

The aesthetic response is based on a relationship of reciprocity between man and world, between the human soul and the soul of the world, between Dasein and Being. According to Hillman, the individual soul is immediately tied to the world soul: "any alteration in the human psyche resonates with a change in the psyche of the world."[29] The integral phenomenon and the ontological *prius* are neither man nor world but a belonging together in an inscrutable third thing.

It was suggested earlier that angels have no message because they themselves are the message. It is the same with animals: like angels "they don't have to tell stories. They just show themselves. They are like images. They *are* images."[30] The juxtaposition of animals and angels in the Hillmanian gnosis is not an arbitrary exercise designed to shock our fragile sensibilities. Hillman merely wants to emphasize that imagination is not a separate faculty operating on its own; it always "works *through, behind, within, upon, below* our faculties." It is like "a permeating ether that dissolves the very possibilities of separate faculties, functions and realms."[31]

Heidegger repudiates aesthetics for reasons that Hillman could certainly make his own. In Heidegger's view, aesthetics is one more disastrous result of our distinctions between the sensuous and the supersensuous, the subject and the object, and

the other distinctions which flow from Plato's original disjunction of *physis* and *idea*.[32] Specifically, what Heidegger rejects is classical sensationalist psychology (Locke, Herbart, Fechner, Bentham, Freud) which, in Hillman's words, "takes one away from the concrete and immediate through elaborate formulations into laws, principles and mathematics." These psychologies advocate "sensation in the service of reason" instead of "sensation experienced through the imagination."[33] According to Heidegger, the classical aesthetics reduce the immediacy of a thing to the *aistheton*—"that which is perceptible by sensations in the senses belonging to sensibility," "the unity of a manyfold of what is given in the senses."[34] In other words, the thing as *aistheton* is conceived as a "throng of sensations" which "lets the *noeton*, the nonsensuous [form] shine through."[35] A distinction is thus made between the real as sensuous and the ideal as nonsensuous. The traditional aesthetics is grounded in metaphysics or, in Hillman's words, it has put "sensation in the service of reason."

If we are looking for a word that in Heidegger corresponds more closely to imagination in archetypal psychology, it is advisable to use his term *Besinnung* (rather than or next to *Einbildungskraft*). For if it is true that, as Hillman repeatedly stresses, imagination takes place within the senses,[36] then the German word *Besinnung* (from *Sinn*, combining both 'senses' and 'meaning') denotes a kind of sensuous thinking ('spiritual perception') whose main characteristic is releasement (*Gelassenheit*) or openness toward things. Like the Taoist action through non-action, it points to a kind of waiting which is beyond the distinction between activity and passivity. In waiting, we leave open what we are waiting for and merely attend, 'stretch toward,' what is going on.[37]

In contrast to calculative thinking which deals with things in terms of personal advantage, *Besinnung*—which is really the same as meditative thinking—involves direct and immediate

reference beyond man to Being, i.e., to things as they are in their concrete, tangible aspectivity. As Heidegger has it, we do not receive sensations because we have sensuous organs; rather, we can have sensuous organs because we are already sensitive beings. Ultimately, the essence of sensitivity lies in the fact that we are finite.[38] We can know and perceive the world because we are a priori worldly or ex-static. We know the world because our personal soul is from the very outset related to the world soul.

IV

Language, Poetry, Art

1. Language as Saying of the Gods

Heidegger's thinking on language is part and parcel of his central project to overcome metaphysical dualism in all its guises. In the dualistic tradition, the 'truest' word is the *verbum mentis*, the mental word or meaning pressing the internal outward into external. Language speaks of sensible things which are taken to be symbolic of the super-sensible. In this view, language is essentially expression and a means of communication. To Heidegger, words are not signs of things nor are concepts signs of words. Things are not prior to words, and words are not labels added to already existing things. "Words and language are not hulls into which we pack things for purposes of speech or correspondence. It is in the word and in language that things become and are things."[1]

Heidegger's experience of language is rooted in what he calls Saying (*Sagen*). Contrary to the conventional assumption that "saying" is posterior to knowing, he holds that saying is anterior to knowing. The communicative and informative function of language is only an incidental trait derived from its essential function which is to name anything that is, non-human or human. Only where there is language is there a world. As Vycinas puts it, "words primarily are not like camera pictures of previously existing things. In words things are brought from their concealment; they begin to be."[2]

Language, Poetry, Art

In Heidegger's famous phrase, which has become a catchword among both his admirers and detractors, language is "the house of Being." This is not a "hasty image," he says; it means that things (Being) are revealed by traversing the house. In other words, we can talk because we have a pre-ontological understanding of Being. We live in language as in "the house of Being." When we go through the forest, we always go through the word "forest" even though we do not pronounce this word or even think about anything linguistic.[3] Indeed, Being itself is linguistic. A thing comes to be, i.e., to "appear," only through language, and where there is no word, there is nothing. Language lets things be. As the poet Stefan George writes: "So I renounced and sadly see:/Where word breaks off no thing may be."[4]

In the conversation with a Japanese visitor, Heidegger suggests that "saying" is related to Tao, the key word in Laotse's poetic thinking. Tao, which is beyond the distinction of subject and object, is "perhaps the mystery of mysteries of thoughtful Saying. . . . "[5] Saying as Tao means "to show, to make appear, the lighting-concealing-releasing offer of world."[6] Saying releases, that is, lets the world be in its pure phenomenality.

According to Heidegger, then, language as saying is not human speech, not primarily a human faculty at all, but that which enables man to stand in the openness of things or in the world. It is an illusion to think that man invented language; man does not invent language any more than he invents Being itself. The only thing he can do is to respond to the address of Being in language. It is not man who speaks but language, for language is in its essence neither expression nor an activity of man. "Language speaks."[7]

In Hillman's writings there are only occasional remarks on language. Generally speaking, however, his stance seems to be similar to that of Heidegger. In a comment on Corbin's *ta'wil* which he understands as "interpretation from above down-

ward," i.e., as "enabling us to experience the sensate world of perception by means of the imaginal world," he says that this kind of interpretation "is another way of describing the gift of tongues brought by the dove." The gift of tongues "is not some special pentecostal babbling, but rather a recognition that the dove is forever possible within our spontaneous speech, that speech is a gift."[8]

Heidegger is convinced that language as saying and the expressions used in such language are neither literal nor metaphorical nor a mixture of both. To begin, the distinction between metaphorical and literal is generated by the acceptance of the Aristotelian system of distinctions, specifically the bifurcation of the 'spiritual' or 'abstract' and 'natural' or 'concrete.' More fundamentally, the literal/metaphorical distinction or the distinction between a direct and an oblique sense "is required by the *positing of rational knowledge* as the aim of thought."[9]

What Heidegger means by "Saying" is, in my opinion, best exemplified in poetry and myth. Owen Barfield, in his work *Poetic Diction*, theorizes that on the most original level of language, words like *spiritus* or *pneuma* (or older words from which these had descended) meant neither 'breath,' nor 'wind,' nor 'spirit,' nor a mixture of these things but rather had "*their own old peculiar meaning*, which has since . . . crystallized into the three meanings specified."[10] It is this process of crystallization that has made it necessary to resort to metaphor as a means of restoring the original unity between the perceiving subject and the percept. In a world torn to pieces by pure intellect, the poet imagines and thus re-establishes relationships which are now expressed as metaphor. Metaphor replaces the simple, given, and experienced meaning of things by created, or shall we say, re-created meaning. It is the same with myth. According to Jung, the thought of the primitives has no detached significance; it is entirely concretistic and always related to sensation.[11] What we

call meaning is enveloped in a wealth of sensuous context: the image is the thing, and the thing is image. To put it in another way: men of archaic societies combine what we today mean by literal and symbolic approaches. Or, as Barfield says, "*our* 'symbolical' . . . is an approximation . . . of *their* 'literal'."[12]

Myths are not metaphorical in the sense of self-conscious creations but natural expressions of man's being in the world. For example, the Homeric hero is not conscious of the fact that he himself is the source of his powers; he receives them as a natural donation from the Gods. The Homeric man "must listen to an echo of himself before he may hear or know himself."[13] In the same way, a great poet does not create poetry apart or in opposition to life but rather as a true (literal) expression of things as they are. He is 'in-fluenced' to reflect the physiognomy of things through which Gods speak. In this sense language does not belong to us: we belong to the Gods who address us through language. Far from being a mere tool possessed by man in addition to many others, language affords man the very possibility of standing in the sheer presence of things.

Thus when Heidegger says that language is rooted in "Saying," he is trying to recapture what Hillman calls the "mythical style of consciousness" or the speech of Gods who dominate and organize our thinking.[14] The Saying of Gods does not need an as-if. For "if we begin in mythical consciousness we do not need the prefix. It is implied throughout, always."[15] In spite of his frequent eulogizing of metaphor and his joining with men like Barfield and Norman O. Brown in a "mafia of metaphor," Hillman would prefer to dispense with the metaphorical "as-if fiction." "Perhaps," he says, "the sharp division between literal and metaphorical in our culture is a manifestation of monotheistic consciousness [rational knowledge], where something must be wholly 'of the one sort or of the other.'"[16]

On the most fundamental level, language is neither literal nor metaphysical but belongs to a style of consciousness that is at-

tuned to what later Heidegger will call the process of *physis*; nay more, it is consubstantial with *physis* in its essentification of things themselves (things as images). Words, used in such a language, according to Hillman, are like angels or "powers which have invisible power over us";[17] they

> sound their own depths of reflection—allusions, alliterations, etymologies, puns, the guises of rhetoric. These resonances in words are singings of angels. We are in the realm of voices, lunacy: the mind sounding itself, sounding its depths, hearing its essential nature as a choir of voices, discordant, antiphonic, responsive, the dead souls in us speaking, ghosts swaying on the family tree, the unborn clustered on the moon, all sounding, talking with our voices and listening, hallucinatory.

In short, words are the messengers who "shine in their own silver"[18] because they are no longer (or not yet) divorced from *physis*.

The kind of thinking associated with the Heideggerian and Hillmanian conception of language is inseparable from perceiving. It is a picture or imaginative thinking that takes place beyond the subject-object distinction and is available to us today only in the imagery of poets and to some extent in our dreams. In Barfield's opinion, we can only understand the origin of such thinking by going back "to the ages when men were conscious, not merely in their heads, but in the beating of their hearts, and the pulsing of their blood—when thinking was not merely *of* Nature, but was Nature itself."[19]

2. Poetic Dwelling

Heidegger has identified language as Saying with original poetizing. Language itself is poetry in the original sense and, conversely, poetry is the aboriginal language. "The essence of poetry must be understood through the essence of language. . . . Poetry never takes language as a raw material ready to hand,

Language, Poetry, Art

rather it is poetry which first makes language possible. Poetry is the primitive language of a historical people. Therefore, in just the reverse manner the essence of human language must be understood through the essence of poetry."[20] Poetry (*Dichtung*), which Heidegger distinguishes from *Poesie* as a literary genre, like language belongs to the very essence of man. As Hölderlin (alias Heidegger) says, poetically man dwells on this earth.[21]

In contrast to the common view which regards poetry as "frivolous mooning and vaporizing into the unknown, and a flight into dreamland," Heidegger takes it as denoting the basic character of human existence—dwelling "on this earth."[22] "Poetry is what first brings man onto the earth, making him belong to it, and thus brings him into dwelling."[23] Heidegger's earth, however, is not the empirically observable and exploitable planet earth, but a subtle earth, i.e., an ensouled phenomenon. This is made clear in the following capital passage:

He [the poet] is one who has been cast out—out into that Between, between gods and men. But only and for the first time in this Between is it decided, who man is and where he is settling his existence. 'Poetically dwells man on this earth.'[24]

To Heidegger, Hölderlin is the poet of the poets precisely because he has devoted his poetic word to this realm of the Between. The mission of the poet is to be a messenger, i.e., to communicate to men what he has learned of the Gods and to name what he has found to be "holy." This naming, however, is not an act of subjective, spontaneous imagination but a response to the speaking of the Gods to man. Poetry, like the meditative thinking of the philosopher, is thanksgiving.

A major consequence of Heidegger's outlook on the nature of the poet is that the latter

is no more considered to be 'creative,' in the sense that he is thought to produce a world of his own imaginings, but to be a

messenger in response to greater powers. The cult of the 'man of genius'. . . is given up. . . . Moreover . . . the subjectivistic and 'humanistic' approach common in the last centuries and largely also today, is abandoned. . . . Man is visualised as standing 'in the open' amid all that is, with things below him and powers above him.[25]

More precisely—how does Heidegger envision "poetic dwelling"? As I already pointed out, poetry for Heidegger, far from being merely ornamental, a "bonus added to dwelling," "first causes dwelling to be dwelling." Instead of snatching us away from the earth or flying fantastically above reality, poetic dwelling brings man onto the earth, makes him belong to it. This is so because poetic images are imaginings in an extraordinary sense: not mere fancies and illusions but "imaginings that are visible inclusions of the alien in the sight of the familiar. The poetic saying of images gathers the brightness and sound of the heavenly appearances into one with the darkness and silence of what is alien."[26]

The poet takes "the measure" from the sky—the dwelling place of the Gods. Gods *are* the measure (*logos*) with which man measures his dwelling, his sojourn on the earth under the sky. Man founds his dwelling on divine standards, i.e., on *mythos*. For Heidegger, therefore, "the taking of measure is what is poetic in dwelling. Poetry is a measuring."[27] A poet, in his capacity of the mediator (messenger) between sky and earth, between Gods and men, is continually bringing things into the open, showing them in their imaginal essence. "Dwelling rests on the poetic."[28] In turn, dwelling is a specifically human way of existing in that it has the character of the "between." The poet's upward glance "spans the between of sky and earth. This between is measured out for the dwelling of man." In the same context Heidegger uses the word "dimension" (*Dimension*) to designate the "Between." "Dimension" is not a stretch of space

but rather "the meting out . . . of the between: the upward to
the sky as well as the downward to earth."[29] The facing of earth
and sky depends on the dimension whose specific nature
Heidegger leaves without name. Man is man precisely in the
spanning. He "dwells by spanning the 'on the earth' and the
'beneath the sky.' This 'on' and 'beneath' belong together.
Their interplay is the span that man traverses at every moment
insofar as he *is* as an earthly being."[30]

We should not be far afield in identifying Heidegger's dimen-
sion or the span as the space of the soul. Soul and imagination,
says Hillman, are a "way of being in the world,"[31] a way of
celebrating the phenomena without agonizing about their
meaning and without suspecting anything noumenal lurking at
their back. Things, perceived imaginatively, are known and
unknown, intelligent and mysterious. In Heidegger's words, the
radiance of the sky is not only sheer light but also "the darkness
of its all-sheltering breadth. The blue of the sky's lovely blueness
is the color of depth. The radiance of the sky is the dawn and
dusk of the twilight."[32] Twilight by its very nature is impervious
to the dissections of the literalistic mentality operating on the
principle of either/or. It is the ghostly region of *metaxis* or
liminality—the place and the time of soul-making, the dimen-
sion that permeates and transforms the profane duration in all
its phases of past, present, and future.

Heidegger also uses the word "holy" (*das Heilige*) for the inter-
mediate region between the immortals (Gods) and mortals
(men). Holiness is not the property of a God (in R. Otto's sense)
but a name for all entities insofar as they display a numinous
aspect; it is an 'ingredient' that awakens, ensouls, and vivifies
everything. Specifically, the holy is identified with the blueness
of the sky. "Blue is not an image to indicate the sense of the
holy. Blueness itself is the holy, in virtue of its gathering depth
which shines forth only as it veils itself."[33] To Heidegger the
blue is not an image *of* the sky but the sky itself. Conversely, a

blue 'thing,' such as sky, is an image. *There is nothing behind the sky as an image*; it speaks for itself and is fully meaningful (holy) in its own right. Or again, blueness, imaginally perceived, is holiness.

Heidegger's identification of blueness with the sky corroborates Hillman's emphasis on the sensate character of images. In archetypal psychology, images can be enhanced by seeing more sense in them, by "attending to it more sensitively, tuning-in, focusing."[34] It bears repeating that the image is not a content that we see but the way in which we see.[35] We find the same insight in Heidegger's discussion of the German word *Wesen*, commonly translated as "essence." *Wesen* comes from the Old High German *wesan*, 'to endure' (*währen*), 'to remain,' 'to abide' (*bleiben*), and it signifies not only what a thing is, the quiddity (essence) of a thing, but also what the thing is with all its particularities (the "minute particulars" of Blake). "The true essense of thing is determined by a relationship . . . to the truth of the momentary existing things."[36] This means that to the notion of what a thing is Heidegger adds the manner in which a thing is the way in which it is seen. In Kaelin's words, "the 'essence' is not only a substantive but an adjectival or adverbial qualification as well." Or: "Of the essence . . . is how things are in play."[37] What this amounts to is that Heidegger's *Wesen* must be understood in the same way in which Hillman understands the 'unknown' Jungian archetype, i.e., adverbially or as archetypal image. The question, for Hillman, is what happens to an image when we call it archetypal. As we intensely watch an image or a string of images (for example, in James Joyce's or Gertrude Stein's novels), the image amplifies *itself*, "grows in worth, becomes more profound and involving";[38] it portrays its own meaning, becomes rich, unfathomable, and hence more archetypal.

We already saw that Hillman's view of images is pre-eminently exemplified in myth. As Bruno Snell, speaking for the archaic

Language, Poetry, Art

Greeks, points out, mythical images need no interpretation; by bursting fully-shaped upon the imagination they reveal to us *of themselves* their full content and significance. For example, the sentence "Hector is a lion" is not only a comparison but also signalizes a factual connection, a kinship between man and beasts. A similar role is applied by Homer to the natural elements: story, wave, rock. They are all regarded as the conductors of fundamental forces that are alive also in man.[39] Barfield has observed that man did not start his career on earth as an unconcerned onlooker facing a separate unintelligible world about which he subsequently invented all manner of myths: "it was not man who made the myths but the myths, or the archetypal substance they reveal, which made man."[40] Snell confirms this anti-projectionist view in the following words: "It is not quite correct to say that the rock is viewed anthropomorphically, unless we add that our understanding of the rock is anthropomorphic for the same reason that we are able to look at ourselves petromorphically."[41]

It is noteworthy that the attempt to restore imagination as the central power not only in man but in nature as well has also been made by alchemists. Alchemy conceived its work as *opus contra naturam* (against the "natural nature") and yet *for* nature in its animated form. Nature had to be deformed for the sake of its own salvation, i.e., in order to free nature in her imaginal aspect.[42] Psychologically speaking, the alchemical opus is coterminous with "imaginal reduction," for what the ancients called *prima materia* is none other than imagination at work within nature itself.

However, while this type of reduction can occur for us only in art, there is no need for art nor for the *opus alchemicum* in the realm of mythical thought. The mythmaker experiences nature at all times as artful and fantastic. In myth, nature 'imitates' itself, whereas for us, the moderns, only art is life as it might be. We can experience the essential nature or the mythical level of

58

being only through the medium of artistic creation. As a commentator on Heidegger expresses it, "Poetic dwelling corresponds to and articulates the mythic." Only poetizing opens up the "measure for things as they *might be* for us . . . things receive their space of possibility through the poetic work."[43]

In view of these considerations, to say that art imitates nature would be as fallacious as to say that nature imitates art. Just as in myth, nature imitates herself, so does art imitate art. And it is in this sense that, let's say, a Hölderlin can be called "the poet of the poet" who writes poetry about the essence of poetry—an occupation which, far from being a symptom of perverted narcissism, is nothing less than holy. For from the standpoint of archetypal psychology, what Hölderlin or any other great poet contemplates in nature is not a reflection (projection) of his empirical being but something more distant and reposeful—a psychic image, an artwork which is consubstantial with his own imaginal essence.

We must imagine the poet as imitating nothing less than the *anima mundi*, for he is a visionary whose powers of perception and imagination extend far beyond the compass of 'natural nature.' Art is not nature at second hand but a second nature. One might also express this in Barfield's terms by saying that we appreciate nature only through the medium of the arts: "We admire not what *we* see but what Corot or Turner, or the illustrator of our favorite fairystories, saw in the landscape."[44] But again, this means that we perceive an already imagined nature or, to put it in a blatantly tautological way, imagination in us imagines imagination that is at work in nature.

3. The Thing

It was stated earlier that Hillman has reduced the things of pre-Heideggerian phenomenology to images. Are we to under-

stand this imaginal reduction as a loss of things? Has the thingness of things, their corporeality, somehow evaporated? The traditional philosophy, which since Plato has maintained that the source of light resides in the intellect, considers the thingness of a thing exclusively in relation to a subject. In the essentialist view, a thing is a substance (an unknown X) to which we attach perceptible properties, called accidents. For example, a piece of rock is hard, heavy, extended, formless, colorful. The thing is not these characteristics but rather that which underlies them. According to Heidegger, to look at things in this way is to turn them into objects of representation: "the image they offer to immediate sensible intuition, falls away. . . . Purposeful self-assertion, with its designs, interposes before the intuitive image the project of the merely calculated product. . . ."[45] The representative mode of thinking, which is also that of science, brings about the universal loss of things by flattening out their inner depth and self-sufficiency, their standing-in-themselves. Things become commodities when they are perceived in their complete unhiddenness, i.e., as objects. Heidegger is not suggesting that the sciences are false. It is only that what they discover and 'prove' is not the thingness of a thing but one of the many possible cases which can respond to an already established view about things. As Barfield says, a scientist discovers an objectified lifeless nature because that is precisely what he is looking for. And "if enough people go on long enough perceiving and thinking about the world as mechanism only, the macroscopic world will eventually *become* mechanism only."[46] According to Heidegger,

> *science's knowledge, which is compelling within its own sphere, the sphere of objects, already had annihilated things as things long before the atom bomb exploded. The bomb's explosion is only the grossest of all gross confirmations of the long-since-accomplished annihilation of the thing: the confirmation that the*

*thing as a thing remains nil. The thingness of the thing remains
concealed, forgotten.*[47]

Heidegger's approach is phenomenological, that is, he intends
to let things be the way they are, to let the thing appear in its
own light. The privileged locus of such an appearing is art. Only
art or, for that matter, poetic thought discloses the thingness of
a thing, for in these disciplines the essences of things show
themselves wholly in their modes of appearances. For example,
when Pindar describes the island of Delos as a star in the sky of
the gods, he does not intend to create a mood or a private
aesthetic response but to celebrate the island. For the Greek
poet, "the effulgence of the divine . . . is reflected in the ap-
pearances of the world."[48] To Wallace Stevens who, like
Hölderlin, writes poetry about poetry, there is an "essential
poem at the center of things." The poem "captivates the
being . . ./What milk there is in such captivity, /What wheaten
bread and oaten cake and kind,/Green guests and table in the
woods and songs. . . ."[49]
Heidegger expresses the "hidden harmony" that obtains
among things when they are quietly observed by saying that a
thing "things." "In thinging, it stays earth and sky, divinities
and mortals. Staying, the thing brings the four, in their
remoteness, near to one another. . . . Nearness preserves far-
ness."[50] The German word *Ding* ('thing') is derived from the ar-
chaic German "thing" meaning "assemblage." To Heidegger a
thing is an assemblage of the Foursome. By assembling the four-
some, a thing assembles or "things" (*dingt*) the world and brings
it into nearness. Miller captures Heidegger's meaning in the
following words: "In the world of images . . . things are both
mindful and passionate, both ideal and real, infinite but very
present, divine and human at once."[51] This is so because
thingness is not primarily a substance but an assemblage and in-
terplay of many things—gods and mortals, earth and sky. In

Vycinas's words, "a thing is essentially thought of when it reveals or assembles the interplay of the foursome—the world. Essential thinking . . . is thus concrete and transcendental at the same time."[52] In Goethean terms, a thing is an *Urphänomen*, a union of the concrete and the universal, paradigmatically expressed in Blake's "to see a world in a Grain of Sand." Heidegger wants to understand the thing on the basis of the Greek conception of *physis* as *logos*, i.e., *physis* as revealing itself in *its own light*. A thing is properly disclosed by letting it appear in its own physical *logos*, in the *logos* of its *physis*.

To say with Heidegger that art discloses the thingness of a thing is not an aesthetic statement. As we already mentioned, the traditional aesthetics assumes that a thing is the unity of sensual data (*aistheton*) understandable only through the manner in which disparate elements achieve summation even when this summation or composition is called the form or a *Gestalt*. "Form" and "content," says Heidegger, are "the most hackneyed concepts under which anything and everything may be subsumed."[53] They are an integral part of a metaphysical tradition which makes a distinction between the real as sensuous (*aistheton*) and the ideal as nonsensuous (*noeton*). In such a scheme, the artwork is turned into an object for our feelings and ideas, and art is treated as a separate and autonomous sphere of experience.[54]

In Heidegger's view, we never just perceive singular data and then combine them into unities. "Much closer to us than all sensations are the things [images] themselves." Things are never first perceived as a throng of sensations. For example, "we hear the door shut in the house and never hear acoustical sensations or even mere sounds. In order to hear a bare sound we have to listen away from things . . . i.e., listen abstractly."[55]

The question we must now consider is: How does the essence of a thing reveal itself in the artwork?[56] Heidegger sees all art as intrinsically poetical, as a way of bringing the Being of beings in-

Language, Poetry, Art

to unconcealment. He describes the art-event in terms of tension between "earth" as the creative ground of things and the "world" which the artwork erects and opens up. An artwork embodies this creative tension between concealment (earth) and unconcealment (world) in a form. Heidegger uses "earth" as a counterconcept alongside the concept of the "world" in order to unravel the ontological structure of the artwork independently of the creator or the beholder. A work of art does not mean something or function as a sign that refers to a meaning; rather, it presents itself in its own being and in such a way that the ingredients out of which it is composed—stone, tone, word—only acquire their real significance within the artwork itself. Art allows things to emerge in their true essence.[57]

A pair of peasant's shoes in Van Gogh's painting *Les Souliers* comes to stand in its own being, is essentified, so to speak, saying in effect: look at what a pair of shoes can be! A great woodcut manifests the wood out of which it is carved; a sonnet reveals its words which now appear as something more than a means of communication. An artwork does not copy anything but rather creates its own living space, a world which simply imitates itself. Heidegger formulates this process by saying that the artist and his work originate in a "third thing which is prior to both, namely . . . art." "Art is the origin of both artist and work."[58] What is meant by this is that the truth (*aletheia*) is not created by the artist nor is it born in an artwork as something which never was; the artist merely spells out, announces, celebrates that which already is "hanging in the air," i.e., the revealing-concealing strife between world (*logos*) and earth (*physis*). Ultimately, Heidegger sees in the work of art an event of truth in the form of a primal conflict (*polemos*) between earth and world. Art proclaims the same process of creation that we observe in nature—a *poiesis* in the sense of making or bringing forth. George Steiner puts it as follows: "The blossom breaking from the bud and unfolding into its proper being (*en eautō*) is, at

63

once, the realization of *phusis* and of *poiesis*, of organic drive—Dylan Thomas's 'green fuse'—and of the formal creative-conservative dynamism which we experience in art."[59]

Heidegger's third that is "hanging in the air" between the artist and his work and out of which both originate is an archetypal image, "the unusual in the usual." In the case of Van Gogh's shoes, the unusual is the essential shoeness of the shoes that shines through the leather work; it is the *Gestalt* (image) or, in Heidegger's words, "the structure in whose shape the rift composes and submits itself. This composed rift is the fitting or joining of the shining of truth."[60] The essence of the shoes is not their quiddity, not a universal, not even a symbol (in the representational sense) but an essential or archetypal image which, intensely watched and closely attended to, amplifies itself and portrays its own meaning. What we thus see in Van Gogh's painting is not an ideal exemplar of a pair of shoes but the whole network of relationships between the shoes, their wearer, and the earth:

> *Out of the dark opening of the worn-out interior of the shoes stares the toil of the work-paces. In the firm massy heaviness of the shoes, the tenacity of tardy walk is stowed—the tardy walk over the far-spread and uniformly matched furrows of the field, over which the harsh wind halts. On the leather lies the dampness and the saturation of the soil. From under the soles slips the loneliness of the country-road in the fading evenings. In the shoes reigns the suppressed call of earth, its silent giving away of ripening grain and its unexplained refusal in the barren fallows of wintry fields. All through this implement the uncomplaining anxiety for the security of bread, the wordless joy of an overcome distress, the shiver at the arrival of a birth and the shudder at the threat of death are drawn. To earth belongs this implement and in the world of a peasant is it preserved.*[61]

Language, Poetry, Art

An artwork as presencing, i.e., making present the tension between earth and world, is called by Heidegger "beautiful." The word "beauty" in both Heidegger and Hillman has nothing to do with art history, art objects, art appreciation, or art therapy. Beauty is not 'beautiful' in the sense of something effete, ineffectual, lovely, and ethereal. According to Plotinus, living ill-proportioned faces have more beauty than lifeless symmetrical ones.[62] In Corbin's thought, beauty is "the supreme theophany, divine self-revelation."[63] It is the theophany par excellence, i.e., the essential condition of *creation as manifestation*.[64] Beauty in the Neoplatonic tradition, says Hillman, is "simply manifestation, the display of phenomena, the *appearance* of the *anima mundi*."[65] It "refers to appearances as such, created as they are, in the forms which they are given, sense data, bare facts, Venus Nudata."[66]

Heidegger traces the German word *das Schöne* to the verb *scheinen*, the root of the word for "illusion" or deceptive appearance (*Schein*). Since, however, Being and appearing are not two entities but one and the same phenomenon, appearing and shining (in the sense of *das Schöne*) also belong together. Things can be beautiful because *physis* is revealing itself and appearing. *Physis* is *schön* (beautiful) because it *scheint-erscheint* (shines-appears).[67]

We can say now that things "thing" about themselves because they are "beautiful," and they are beautiful because they thing about themselves. Things are colossally, unabashedly narcissistic. In other words, beauty is simply that which shows itself from itself. In this sense everything is beautiful as long as it appears in its truth (*aletheia*). Being, Truth, and Beauty are one.

The thinging is variously called by Heidegger "the mirror-play" of the foursome, the "round-dance," or the "worlding" of the world. The fouring "presences as the worlding of world. The mirror-play of world is the round dance of appropriating."[68]

Thinging of things is fouring is worlding is round-dance is mirror-play of the world. We already saw that in Heidegger's thought the word "world" is not used in the sense of a place or as a term designating some imaginary totality of entities. Rather, the world is apprehended as the ultimate context of human life, i.e., as the "mirror-play of the simple onefold of earth and sky, divinities and mortals."[69] Elaborating on this statement, Heidegger says that things penetrate each other by traversing a middle. In the middle between the world and things, a unique "dif-ference" prevails. The dif-ference, however, must be understood in the deeper sense of *dif-ferre*, a "bearing of each other out" (the *cum* of correlation), a common measure, or a primal unity, by which each adheres to the other and out of which both issue forth.[70] The dif-ference is a mysterious "third thing," the genuinely ultimate giving-rise to the correlation between Being (the world) and beings (things). Like the Jungian "psychic reality," it is the mediating im-mediacy, the *fons et origo* from which everything proceeds. In ar-chetypal psychology, psyche is the mediating source of meaning, a large and open space beyond which there is nothing in the sense of a grounding ground or *primum mobile*. There is only a ceaseless proliferation of images, imagination imagining *ad in-finitum*.

Heidegger's "third thing" is *poiesis* or what Hillman calls "the poetic basis of mind" which is the same as *mythos*, the saying of the *logos* of the Gods. All human thinking and poetizing is therefore a "making in the shapes of the Gods, and a making of our lives mimetic to them."[71] W. Otto has shown that Gods are not singular beings alongside the other beings or things, but worlds. Zeus, Athene, Hermes never "merely represent a singular virtue" and are not found "merely in *one* direction of vividly moving life; each of them fills up the whole extent of human life with his peculiar spirit—forms it and illuminates

it."[72] Gods are imaginal worlds we inhabit, and every thing in these worlds becomes a thing (image) by reflecting a God. Things are microcosms mirroring the macrocosm (*anima mundi*).

When Heidegger says that the mirror-play of the foursome is the "worlding of the world," he is not implying that the world is posterior to the four of the foursome. The interplay of the four *is* the world. The mirror-play, therefore, can never be thought of as the play of four beings: "The four of the foursome do not enter the round-dance as something in themselves already . . . they becomes [*sic*] what they are, they appropriate their essences, only in this round-dance of the world."[73] In this sense the round-dance is something ultimate beyond which there is literally no-thing. Man has no other task or mission except "to treat with consideration, to spare everything whatsoever . . . i.e., to let-it-be assembled in the openness of world or in the *logos* of *physis*."[74]

Casey has observed that Heidegger's foursome (or tetrad) of man, sky, earth, and Gods, for all its comprehensiveness, cannot account for the multiplicity of archetypal figures. Gods cannot allow themselves to be "lumped together under the one generic heading of 'gods'."[75] To Jung, Corbin, and Hillman, imagination is inherently protean, polymorphous, and immeasurable, and the immeasurability of imagination demands the immeasurability of the Gods. Hillman also holds that imagination is immeasurable in the specific sense that it is not numerable: it is "innumerably full of innumerable kinds of things . . . this imaginal region of the psyche, does not submit to numbering."[76] In my opinion, Heidegger's subsumption of all the Gods under the heading of "Gods" is primarily due to a lingering nostalgia, perceptible throughout his writings, for Nature as the Great Mother, i.e., the abysmally divine element inhering in what he calls the earth or *physis*. The earth reflects

the divine but not Gods, hence it is immaterial to Heidegger
how many Gods there are, whether they are numerable or in-
numerable.

Moreover, the estimation of the earth as being in some sense
imbued with the divine has led Heidegger to adopt a generally
negative attitude toward technology and by the same token
toward things that are manufactured by the technological soci-
ety. It is not part of my project to treat Heidegger's thought on
technology. Let it only be said that Hillman's recent writings
seem to offer a broader and more charitable view of things, in-
cluding things that are not 'natural.' Hillman wants to go
beyond ecological concerns about the balance of nature so as to
see the Platonic *anima mundi* as soul-in-the-world in tables, cars,
shoes, tin cans, plastic. "We have to open our minds to the pos-
sibility of soul everywhere: we can't exclude things from it and
love only nature." But, then, how do we perceive soul in every-
thing? Obviously, says Hillman, we do not mean that "the shoe-
lace experiences, remembers, feels, that it loves being tied into
knots and hates hanging around loose . . . " or that "the
ashtray waits for burning cigarette stubs with a masochistic
pleasure." Seeing soul in the world is not an attempt to revive
primitive animism or anthropomorphism. The only way for us,
the moderns, to experience the soul of an object is "to think of it
as a form or as a shape or a face, an image. . . ." An object is a
"phenomenological presentation, with depth, a complexity, a
purpose, in a world of relations. . . ." Soul has to do with an
aesthetic appreciation of how things present themselves, how
they show their faces, their physiognomy. Hillman's way of
looking is "a combination of the Neoplatonic *anima mundi* and
pop art: that even a beer can or a freight car or a street sign has
an image and speaks of itself. . . ."[77] *Pace* Heidegger, Gods are
hiding not only in the primal forests and mountains of the earth
but are present—incognito—in the streets of the cities as well.
All things are divine so long as they are approached with con-

sideration and care, that is, when we let them be as what they are—images.

4. *Physis and Soul*

It is often said among the traditionalists (representatives of "perennial philosophy") that the kinship between mind and matter was severed during what Yeats called "three provincial centuries" (seventeenth to twentieth): nature was declared to be matter and to be dead. An unbridgeable gulf was created between *psyche* and *physis*. Heidegger, for his part, would trace the beginnings of the solidification of matter to Plato's declaration that appearances are only true insofar as they accord with the ideas (reality). It is at this juncture that *physis* becomes mere matter exposed to the hegemony of the active, ordering, and spiritual principle located in the mind. *Logos* is gradually flattened into logic. In Vycinas's words, "*logos*, as cut off from *physis* and standing by itself or for itself, becomes the perverted *logos*, logic. *Physis*, on the other hand, when thought of separately from *logos*, becomes perverted *physis*, matter."[78]

To the early Greeks, *physis* was Being itself which they considered through the phenomena of water, air, *apeiron*, or fire. Originally, *physis* (from *phuein* 'to grow') meant, not merely development or becoming, but also a primordial stepping out of concealment into the light of the real. Instead of being a passive principle, opposed to the active or spiritual principle, nature is a constant coming and breaking forward, the appearing. Heidegger, like the early Greeks, holds that appearance is physis itself which, by coming forward, establishes an open realm (cosmos). Put differently, *physis* is Being as *aletheia*, the coming into light. *Physis* is *logos* (ideas), the same *logos* through which we see the world and the world sees us. *Physis* as *logos* is also soul, and physio-logy is psycho-logy.[79]

69

Language, Poetry, Art

In Heidegger's philosophy, nature is not opposed to spirit. "Nature is thinking, and by the thoughts of nature everything has its place. By standing in nature, and thus in the thoughts of nature, man guards these thoughts—he thinks."[80] *Physis* as *logos* is the ultimate source of thought as well as of language and poetry. The human *logos*, as it shows itself in language and poetry, is merely a response to the *logos* of *physis*. Man is disposed to nature, not nature to man.

Heidegger's notion of *physis* is best understood in the sense of creative occurrence, i.e., as the *poiesis* of *physis*, the originating "bringing forth," "producing." The producing of *physis* is an origination emerging out of itself: "The Greeks did not learn what *physis* is through natural phenomena, but the other way around: it was through a fundamental poetic . . . experience of being that they discovered what they had to call *physis*."[81]

It is a commonplace in Heidegger, however, that the revelation of *physis* (Being), if it is to preserve its creative power, must be accompanied by a simultaneous concealment and withdrawal. As in Heraclitus, truth (*aletheia*) is a primordial strife (*polemos*) between light and darkness, revelation and concealment. Conflict, instead of destroying unity, is constitutive of unity, for opposites in nature as well as in human life are not contradictory (as in logic) but polar. Polar opposites exist by virtue of each other and at the expense of each other. Unity originates in conflict or, rather, the conflict, in the sense of polar relation, is itself the originating unity of opposites. The conflicting powers belong together precisely insofar as they oppose each other; their antagonism is the very source of their essential oneness.

To indicate Being's penchant for concealment, Heidegger refers to Heraclitus who (in Heidegger's translation) said: "Being (*physis*) loves self-concealment." To this he adds: "Since Being means the coming-forward appearance, the stepping-out from concealment, therefore concealment and arrival from concealment essentially belong to Being."[82]

Language, Poetry, Art

Now it is precisely because of this proclivity to concealment on the part of *physis* that truth as correctness of vision could take precedence over truth as *physis*. What Western metaphysics forgot was the 'physics' of truth. Hillman would certainly have no difficulty in agreeing with the Heideggerian diagnosis, since he too deplores the fact that the *logos* in the Western tradition has been defined exclusively in terms of Olympian structures as form, law, etc. In an effort to rectify this divagation, Hillman proposes to replace the ossified *logos* of formal logic with a Dionysian *logos* representing the voice of nature herself—nature perceived as "both *natura naturans* (the primordial force of nature) and *natura naturata* (the primordial forms of nature, the ambiguous but precise archetypal images)."[83] Dionysus, says Hillman, is not dumb. He is not only a blind force, the *élan vital* of vegetative life, but also "the soul of nature, its psychic interiority. His 'dismemberment' is the fragments of consciousness strewn through all life. . . ."[84] The Dionysian nature is *physis* and *logos* in one, a "coadunation" (Coleridge) of the internal and the external, making the internal external and the external internal.

Vycinas has shown that Heidegger's notion of strife between earth and world (which is parallel to that of *physis* and *logos*) reflects the conflict between Chthonian and Olympian powers in the Greek religion. In the Homeric Greece, *physis* or the Chthonian religion is unthinkable without *logos* or the Olympian religion. *Physis*, as we pointed out, is the breaking-forward of *logos* itself. *Logos* is always the *logos* of *physis*. In the same way, Dionysus is never merely chaotic and dangerous but also order-creating; even as a Chthonian deity, he stands at the extreme limits of the Olympian light. He brings together the broad sky and the dark earth, the Olympian Gods and the Chthonian powers. Thus "he announces something which is difficult to grasp, easy to lose, and which, nevertheless, is more real than anything real."[85] Dionysus is the God of the elusive region between day and night, life and death, the spiritual and earthly.

Language, Poetry, Art

Like the early Greek phenomenon of *physis*, he is a subtle reality uniting spirit and nature. As W. Otto has explained, nature for the Greeks retains its entire fullness and liveliness and at the same time is one with the spiritual: "Immediate corporeal presence and eternal validity as being one and the same is the miracle of Greek form-creation. And in this unity of spirit and nature the earthliness comes forward with freedom of proportion and a sense of elegance as complete nature."[86]

To conclude, the Heideggerian *physis* seems to be closer to the psyche than to nature in its degraded 'material' form. Far from being the sum total of natural things, it is the potency or the internal principle of things—the dark abyss, the yawning gap, and at the same time the groundless ground of everything. In her presencing or appearance, *physis* expresses the creative essence (imagination) or nature, the *poiesis* of *physis*. "Presencing," as indicated earlier, has for Heidegger the original sense of creative occurrence. Thus when he says that Being reveals itself as *physis*, he means that Being prevails in the same way in which the "overpowering powers" of Nature prevail, i.e., like waves of the sea as it "unceasingly tears open its own depths and unceasingly flings itself into them" or like dominion of the overpowering powers of the burgeoning, nurturing, and towering earth.[87] Being 'essentiates' in displaying itself and in "playing."

V

Play and Earth

1. The Inscrutable Play

Heidegger's thought reaches its apogee in the controversial and puzzling idea that *physis* or Being rests in itself, in its own "play."[1] The creative *dynamis* of *physis* is not secured in anything that can be described as ground, reason, supreme intelligence, and the like but in the mystery of play. Being is that which lies forth of itself and cannot be measured by rational standards or captured in a ready-made scheme of concepts. As the soul is the immeasurable which measures us, so it is not man or human reason which is the measure of things but Being itself.

The essence of play, according to Heidegger, has nothing to do with leisure providing an interlude from the seriousness of 'work.' Rather, the mystery of play is akin to that highest and most absorbing play of which Heraclitus speaks, the play of *aion*, i.e., of the world as the dispensation of Being. The child who moves the counters in the game, says Heraclitus, possesses the "royal power" (fr. 24, Wheelwright). "The play of Being is the revealing-concealing process within Being. It is a game of 'hiding' itself from us in the very act by which it reveals itself . . . an 'elusive' (*e-ludens*) game by means of which the truth of Being eludes the grasp of metaphysics."[2] The childish playtime is a creative, non-human occurrence, an Event

Play and Earth

(*Ereignis*) that, in Zen language, happens 'just so' and is 'nothing special.' The child plays with gravity, he is transported beyond himself, he is *in* the play, because fundamentally the "royal power" belongs to the play itself. The play (like *logos* and *physis*) has no ground apart from itself. It is groundless play, a dance, a "ring," a "mirror-play of the world" of the foursome—an alluring illusion that thrives on the elusive. Another way of putting it would be that the child has 'reduced' things—playfully—to their imaginal essence or to the "poetic basis of mind." "What remains to be said?" asks Heidegger; and he answers: "Only this: Appropriation appropriates."[3]

The Heideggerian tautologism means that the "poetic basis of mind" is also the basis, the groundless ground of nature. Or: soul is the soul of the individual man as well as *anima mundi*. In the mirror-play of the world, soul and nature mirror each other because both are essentially *poiēsis*, a "making in the shapes of Gods."[4]

Heidegger elaborates on what is meant by "play" in his discussion of Leibniz's "Principle of Sufficient Reason" which says that nothing is without reason or nothing is without ground. Leibniz's principle asserts that every being must have a ground in another, and ultimately in a highest or supreme, being. This, of course, sounds innocuous enough. What irritates Heidegger, however, is the emphasis on man: it is man who always demands reasons; the ground must be given to man. Leibniz, by making man the measure of all things, extols human subjectivity. Heidegger then shows that seeking for grounds results in an "infinite regress" and concludes that every beginning, every first principle, involves some kind of faith or arbitrary decision which in the end forces us to enter a "dangerous region," a "twilight zone"—the groundless. "This region is known to many thinkers although they rightly say very little about it."[5] Moreover, the demand to give grounds has the effect of robbing

us of our rootedness in soil upon which we have always stood, for the more we pursue grounds the more we lose our footing.[6]

In order to illustrate a new way of thinking which is not confined to giving reasons and which rests on the "play of Being," Heidegger refers to the verse of Angelus Silesius, the seventeenth-century mystical poet and the versifier of Meister Eckhart: "the rose is without why; it blooms because it blooms;/It cares not for itself; asks not if it's seen."[7]

According to Heidegger, the poet is voicing the conviction that "man, in the most concealed depths of his being, first truly is when he is in his own way like a rose—without why."[8] The ground revealed to the poetic thought is groundless ground, an abyss (Ab-grund). As such it is a mere play: "It plays because it plays. . . . The 'because' submerges in the game. The game is without 'why'. It plays while it plays. It remains only play, the highest and the deepest."[9] To use Hillman's expression, Silesius's rose has its "own gleam and ring"; it is self-referential. Or, as Heidegger says, "the blossoming of the rose is grounded in itself; has its ground in and of itself. The blossoming is a pure emerging out of itself, pure shining."[10] The rose, like physis, is a self-sufficient process; it needs no external justification, no rationale for its being-there. In the same way, Dasein, having suspended calculative thinking, must let things be in their thinging, self-resplendent with their own grounds.

Caputo has suggested that the rose in Silesius is the model for the soul. The mystical poet wants to say that the soul should become like the rose, that man should free himself from the search for grounds and reasons. The "startling discovery," made by Silesius, is that of a region outside the sphere of influence of the Principle of Sufficient Ground and outside of representational thinking itself. An access has been opened to another region "where there are no 'objects' but only 'things' (Dinge) which are left to 'stand' (stehen), not 'before' (gegen) a subject,

but 'in themselves' (*in sich selber*). In this region . . . 'things' rest on their own grounds."[11]

Reiner Schürmann has characterized Heidegger's play in terms of Meister Eckhart's injunction to "live without why,"[12] that is, without purpose. Eckhart, like Heidegger, advocates the abandonment of a metaphysical First, of an *archē* conceived as an ultimate point of reference (substance in Aristotle, the Christian God in Scholasticism, the Mind in Hegel, etc.). Schürmann speaks of the anarchic essence of Heidegger's thought, of Zen and Eckhartian mysticism. The term "anarchy" is understood here not only as the absence of a beginning, of an origin in the sense of first cause, but also as a negation of the complement of *archē*, namely, *telos*.[13] Heidegger's Play of Being is anarchic and atelic, an inscrutable play in which *lethē* is never entirely overcome.[14] The depths of Being (*deitas abscondita?*) are hidden not only from us but from Being itself. Being, like the soul in archetypal psychology, is "without why." Like the rose of Angelus Silesius and that of Gertrude Stein as well, the soul is a soul is a soul.

Hillman alludes to a similar state of affairs when he says that the infinite regress implied in imaginal reduction only stops at the reality of the soul. But even at this juncture, the soul is no more than a metaphor: "More real than itself, more ultimate than its psychic metaphor, there is nothing."[15] Hillman also rejects the idea that origin is something which lies in a literal (objective) past. Attempts to trace everything to a source do not solve anything. The fantasy of objective origins disguises the psychological truth that "the ultimate source is . . . in the enigma . . . of the imaginal . . . in the *mundus imaginalis*."[16] The past as well as the future are *now*, for the goal (*telos*) is a "dynamism *now* at work in a complex. To separate out the *telos* is to separate way and goal."[17]

According to Heidegger, the past must not be understood in the sense of *Vergangenheit* ("pastness" suggesting something by-

gone) but as *Gewesenheit* (from the past participle of *sein* 'to be')—"having-been-ness or alreadiness." "Alreadiness" brings out the point that the past lies not behind but in front of man, structuring man's present and future.[18] We can move toward the future only by moving toward the past. Our past is in our future. In this sense, to live authentically is, in Pindar's words, to "come forth as what thou art."[19]

Clearly, our need for security, as well as our Aristotelian grammar, cannot easily accommodate the idea of a beginning that has no cause but rather issues forth, tautologically, from itself. Zimmerman describes this "scandalous" situation as follows.

> *We find it almost impossible . . . to regard our experience just as a series of happenings; instead, we filter it through all sorts of projections and interpretations, including scientific theories about the structure of "reality," and religious claims about the "meaning" of it all. We tend to be so purposive and willful that the world appears only as a set of goals and obstacles. In viewing the world this way, we are shut off from its primal mystery: that events are constantly happening, and that the play of appearance is going on at all. These happenings (beings, events) require a place (time, absence) to happen (to be manifest). The place does not come from outside of the happening, but is intrinsic to it. Presencing and absencing happen together, or "give" themselves to each other. The play plays because it plays. We are most ourselves when we participate in this play.*[20]

The play-time is the time of gnosis which is also the time of soul-making. For the soul, time has no *archē* and no *telos* in any objectifiable sense. But this is the same as saying that the time of the soul is always now, i.e., in the very midst of transiency and mortality. Beginning always begins; end is in the beginning, and beginning is in the end. In Casey's words, soul-making is "a movement without definite end, issue, or outcome," hence "in-

finite in the root sense of end-less, without an exact end, unending. Of time in the soul . . . regarded as perduring process of permutation and percolation, we have to say . . . *there is no end to it.*"[21]

Another word for Heidegger's sublime play is circulation or circumambulation—a notion encountered in our discussion of the hermeneutical circle. The circle, we said, is neither vicious nor holistic but eristic, and the kind of knowing available within the circle is radically finite. According to Hillman, the movement of the soul is not "a progressive march whose retreats are only for a better leap forward (*reculer pour mieux sauter*)" but more discontinuous in that it includes "the downward turns, the depressions, recessions, fallings-away from awareness."[22] The reason for this deviancy is that the journey itself is the goal, not some sort of aseptic utopia at the end of the road.

Indeed, the journey is a circumambulation around a center which is never possessed because it is ubiquitous. The soul in archetypal psychology is by definition polycentric. The alchemical symbol for this circulation is the uroboros, the coiled serpent representing time and the eternal return of the same. In a disquisition on Nietzsche's metaphor that man must bite off the head of the serpent which has crawled into his mouth, Heidegger suggests that the image of uroboros points to the necessity of facing and positively affirming the transiency of time.[23] What he presumably means is that the uroboric course is not so much an eternal circling (the most awesome thought to Nietzsche) as it is following Hermes, the psychopomp, the primordial mediator and messenger who, in Karl Kerényi's words, always stands in "a middle between being and non-being," who is "at home while wandering, at home on the road itself." Hermes is *hodios* ("belonging to the journey"), constantly in motion. Moreover, the roads on which he travels are genuine roads of the earth, running "snakelike, shaped like irrationally waved lines . . . winding, yet leading everywhere."[24] The elusiveness and

duplicity of Hermes are expressed by Heidegger in his character-
ization of Dasein as being simultaneously in truth and
untruth.[25] The very essence of man is "errance" (*die Irre*): "the
errance belongs to the inner constitution of Dasein . . ."; it
"dominates man by leading him astray."[26]

In Hillman, errancy is a companion of Necessity (*anankē*); it is
through errancy, through error-caused events, that Necessity
breaks into the world. "Necessity" is the archetypal background
of error and as such is an essential component of the imaginal
psyche itself.[27] There is something inexorable in the way the
psyche behaves: its images have their own necessity insofar as
their meaning cannot be separated from their appearances. Im-
ages are necessarily, essentially what they are. It is also for this
reason that fantasy, says Hillman, far from being a carefree day-
dreaming, is the "implacable carrier of the necessities that drive
us. Psychic reality is enslaved to imagination. . . ." Or again, im-
ages are said to be "primordial, archetypal, in themselves
ultimate reals, the only direct reality the psyche experiences. As
such they are shaped presences of necessity."[28]

To wind up the preceding thoughts, let me juxtapose two
passages, one by Hillman, the other by Heidegger, conveying as
plainly as one might wish the soul's affinity for circling. Speak-
ing about the pervasive presence of unconscious motivations
(imagination) in our conscious life, Hillman says:

> *We are dreaming all the time. . . . Part of the soul is constantly
> remembering in mythopoetic speech, continually seeing, feeling,
> and hearing* sub specie aeternitatis. *Experience reverberates
> with memories, and it echoes reminiscences that we may never ac-
> tually have lived. Thereby our lives seem at one and the same mo-
> ment to be uniquely our own and altogether new, yet to carry an
> ancestral aura, a quality of* déjà vu.[29]

In almost identical terms Heidegger speaks in his lectures on
Schelling of "that weird (*unheimlich*) and yet friendly feeling that

79

we have always been who we are, that we are nothing but the unveiling of things decided upon long ago."[30]

In religious history and myth, circularity is closely related to the image of the ladder whose rungs in themselves do not lead anywhere in particular. The rungs of the ladder merely ascend and descend, for, as in Heraclitus, "the way up and the way down are the same" (fr. 108, Wheelwright). 'Circularity' and 'ladder' make it possible for us to dispense with the idea of a hierarchically constructed universe which has been a necessary part of the Western metaphysics of light. Hierarchical models are essentially static, and the movement of ascent from the lowest to the highest is unilinear. In Hillman's view, it is better to speak of "polycentricity, of circulation and rotation, of the comings and goings of flow. In this structure all positions are occasionally inferior, and no positions are ever finally inferior."[31] Miller points out that the ladder "is not hierarchically graded like the Great Chain of Being. . . . Rather, each and every one of its rungs is a differentiation, an articulation in an individual way, an image and trace of the One in power and in polytheistic manifestation."[32]

The fearful question we must face, however, is this: What happens to the soul when it goes down the ladder? In a brilliant essay on the descent into Hell which is also an exercise in gnostic imagination, Miller emphasizes that the Latin word *inferos* in the expression *descensus ad inferos* is from *in-fero*, meaning "to carry inward," to "gather in." The journey into hell is "descent into the imaginal," and hence it is actually "the ascent of the soul," providing the ego "a perspective from a soulful point of view."[33] As universally exemplified in the myth of the hero, the descent means, not extinction pure and simple, but a confrontation with danger (watery abyss, cavern, forest, etc.) resulting in the acquisition of the "pearl of great price." Hillman, as if pointing to what Heidegger will later call Gelassenheit (releasement), says that "the descent is for the sake of moistening. Depression into these depths is experienced not

as defeat . . . but as downwardness, darkening and becoming water. (A major caution in alchemy was: Begin no operation until all has become water.)"[34] Note also the Buddhist admonition: become like water! Moistening, becoming like water, is a therapeutic move aiming at transformation of the usual egoic and literal stance into an imaginal, non-personal way of being. Jung describes this process as follows: "To the extent that I managed to translate the emotions into images . . . I was inwardly calmed and reassured. Had I left those images hidden in the emotions, I might have been torn to pieces by them. . . . I learned how helpful it can be, from the therapeutic point of view, to find the particular images which lie behind emotions."[35] Jung's point is that emotions or, for that matter, literally everything we call "our experience" (our gorging on experiences!) can be used as material for soul-making provided we learn to watch the flow of experience instead of identifying ourselves with it. To become like water one must first learn to pay attention to water.

So then—where do we go when we go down? Where is "hell"? Miller's answer is unequivocal: "Hell is in the 'middle,'" i.e., 'in' the soul. But, of course, he continues, "to the ego it seems, not a middle but only an unimaginable muddle. And so the question of the prophet Isaiah (6.11) persists with us always and seemingly forever in our daily descents: 'How long, O Lord?' How long must we be in the middle, between heaven and earth, between death and life, always between? How long?"[36] The answer is radical and forthright: "Forever."[37] We are permanently, "ultimately" on the threshold, on the crossroads, in Jasper's "limit-situations." We are forever in Hell. But not to worry! Or, as Watts says, if you worry, worry. Go into your worry. Descend. For something else, sooner or later, is bound to happen. An "abominable fantasy" is bound to happen.

The expression "abominable fantasy" was used by a nineteenth-century cleric[38] in connection with the Christian teaching regarding the suffering and/or bliss of persons in post-

mortem states. In the Christian tradition, hell is said to be ever-lasting, and no *apokastasis* of the demons and the wicked is envisioned. The ostensible reason for such a morally offensive doctrine is that eternal suffering constitutes a strangely, 'abominably' blissful experience. Specifically, the bliss consists in watching the eternal torment of the damned in hell.[39]

Psychologically, we are confronted here with sado-maso-chism: experiencing pleasure accompanied by pain and vice ver-sa. Sado-masochistic phenomena, according to Jung and Hillman, are part of "the twisted nature of the psyche, its com-plexity. . . . Our complexes are twisting-together of oppo-sites. . . . We are twisted in soul because soul is by nature and of necessity in a tortuous condition."[40] *"Soul-making entails soul-destroying"*[41]—a process that is similar to what happens in the alchemical opus. In the same way, the eternal bliss of the blessed is unimaginable without the eternal torment of the damned. When all is said and done, the *desensus ad inferos* is *already* and at the same time a redeeming or at least a therapeutic event which is dichotomized into two events—joy and suffering—only by the ego. The "abominable fantasy" is abominable and obnoxious only from the perspective of the ego. Miller, therefore, can write in a truly Heideggerian spirit: "It is now not that *I* am tormenting *someone* or that *someone* is tormenting *me*. It is now not a matter of ego at all. Rather, more fundamentally, a *torturing* is going on. There is no reference to a torturer or to one tortured. The torment is no longer taken per-sonally. Rather the torturing is going on purely and simply. . . ."[42] Miller's statement is a psychological version of Heidegger's *aletheia*—an event of simultaneous revelation and concealment, truth and error, *logos* and *physis*. Put differently, hell and heaven are events of the soul—a sheer occurrence, a Play in which the "royal power" belongs to the Play itself. Thus the blessed are not sadists, and the damned are not masochists. Rather, says Miller, "the belonging-together . . . of love and

hate, of life and death, of torturing and being tortured is simply the ways things are."[43]

It is gratifying to find that Heidegger, in spite of himself, as it were, is not averse to psychologizing when he is engaged in the interpretation of the poetic saying. I have already referred to the way in which he understands George's lines "When the word breaks off no thing may be." We must now listen to the treatment he accords to the immediately preceding sentence: "So I renounce and sadly see. . . ."

Heidegger writes that the poet should rejoice at the experience of renunciation because it "brings to him the most joyful gift a poet can receive . . . renunciation is not a loss. . . . " Sadness is something to be "learned." It is "neither mere dejection nor despondency. True sadness is in harmony with what is most joyful. . . ."[44] In a later comment on George's lines we are told that

> the more joyful the joy, the more pure the sadness slumbering within it. The deeper the sadness, the more summoning the joy resting within it. Sadness and joy play into each other. The play itself which attunes the two by letting the remote be near and the near be remote is pain. This is why both, highest joy and deepest sadness, are painful each in its way. But pain so touches the spirit of mortals that the spirit receives its gravity from pain. . . . [Pain] can depress the spirit, but it can also lose its burdensomeness and let its 'secret breath' nestle into the soul, bestow upon it the jewel which arrays it in the precious relation to the word, and with this raiment shelters it.[45]

In conclusion, let us ask an apparently naive question: Where does Heidegger's Play take place? It was already suggested that heaven and hell are not places but events of the soul. This, however, should not be understood in a spiritual sense: an event of the soul is not a purely spiritual event having nothing to do with matter and the material. Rather, it is an imaginal

event which *has a place*—a place made by the soul. Heaven and hell *are places* made by the soul. The Play, therefore, is not something spaceless and timeless; it does not take place in an eternal now but in space and time engendered by the soul and in the soul. In terms of Corbin's theosophic thought, the Play happens *in medio mundi*, the space of visionary geography which he also calls "Celestial Earth."[46] It is to a consideration of this Earth that we must now turn—an Earth which supports and nourishes without being materialistic and which is celestial without being spiritual.

2. The Truth is on the Moon

In Heidegger's thought the earth reveals all things in their true forms and colors through the medium of an artwork. Earth is revealed only in art. For example, marble is truly marble, not as perceived in native rock, but only when it is placed in a wall or pillar of a Greek temple. Gold is revealed as gold in the spear of Athene. An artwork allows the materials out of which it is made to stand out, to appear in their true earthliness. However, as Vycinas explains, the earth, in its very appearance, clings to itself and remains unexplained and concealed. The earth appears and at the same time conceals itself in stone, wood, color, tone, or word. All these are "educed" into a world (*logos*) by the artwork and revealed in their true "nature."[47]

Nature in Heidegger, like among the Homeric Greeks, is supremely real and yet constantly eluding any attempt to grasp or to possess it. "It is ghostly and in a certain sense dreadful . . . beautiful and fascinating; frightful and mysterious with mountains, meadows, and forests lying in the silvery light of the moon."[48] Like Being, nature can never be conquered. Any attempt to reveal the earth completely by the use of scientific method is doomed to failure. The earth "only shows itself,"

says Heidegger, "when it remains undisclosed and unexplained. Earth shatters any attempt made to invade it."[49] When science believes that it gradually penetrates and possesses earth, it deceives itself because it ignores earth as earth. In Vycinas's words, "what science deals with are merely scientific mechanisms which are being *quasi* forced upon the earth, and the answers obtained that way are only answers previously placed into it by the sciences themselves, i.e. answers which have more to do with the sciences than with the earth. . . . Only an artwork is adequate for revealing the earth because . . . it shows it the way it is."[50] Heidegger is not saying that a work of art causes the earth: "To bring earth forward means to bring it into openness as concealed-in-itself." The true earth "shows itself only when it remains undisclosed and unexplained."[51] The process of revealing/concealing is the strife between the world (*logos*) and the earth (*physis*). But, as we observed earlier, this strife is not destructive, for "in an essential strife . . . the strivers raise one another into self-affirmation of their essences."[52]

The modern technological man has become a stranger to the earth—in spite of his frantic preoccupation with material things. He is no longer at home on earth because he has imprisoned himself within his own self-made world—the world of subjectivism parading as dispassionate objectivity. Heidegger seems to be convinced that we are presently living in a phase of accelerated deterioration of all that makes human existence worthwhile:

> The spiritual decline of the earth is so far advanced that the nations are in danger of losing the last bit of spiritual energy that makes it possible to see the decline . . . and to appraise it as such. . . . for the darkening of the world, the flight of the gods, the destruction of the earth, the transformation of men into a mass, the hatred and suspicion of everything free and creative, have assumed such proportions throughout the earth that such

Play and Earth

childish categories as pessimism and optimism have long since become absurd.[53]

The question, then, for Heidegger and for us is: How to establish a true relationship to the earth? It is clear from the preceding that Heidegger's earth has nothing to do with the material earth investigated by natural sciences. Heidegger is not a victim of "the naturalistic fallacy" which, in Hillman's words, "identifies the element Earth with natural dirt and soil: to be earthy, we must be dirty and soiled."[54] Infatuation, in many contemporary quarters, with what is perceived as earthy is merely the obverse side of a spiritual flight from the earth, a compensatory strategy failing to see that both the spiritual and the natural are more solidly grounded in a third thing, the soul. In short, our task is to find "another earth that would give support and yet not be materialistic."[55]

In a treatise on Georg Trakl's poetry, Heidegger calls the soul (in the words of Trakl) "something strange on earth." On the face of it, the idea of the soul as stranger would seem to agree with the Platonic view that the soul is destined to escape from the shackles of physical existence, from its pilgrimage on earth, so as to rejoin its true home in eternity. Heidegger, however, interprets Trakl's words in such a way that the traditional Platonism is turned upside down. The soul is a stranger on earth, not because its true home is elsewhere, but because it has not yet found its true home, its proper place on earth. "The soul only *seeks* the earth; it does not flee from it." And it is this seeking that "fulfills the soul's being: in her wandering to seek the earth so that she may poetically build and dwell upon it, and thus may be able to save the earth *as* earth."[56] Soul's being lies in her wandering, in her uroboric course. The soul is a stranger on earth, not because she is made of a different stuff, radically alien to the stuff of the earth, but rather because she has not yet recognized her belongingness to and her consubstantiality with the stuff the earth is made of.

Play and Earth

Even more surprisingly, the soul, in her wandering, is called to go down into the peace and silence of the dead. Death, however, is not understood by Heidegger as the conclusion of earthly life: it is "neither a catastrophe, nor . . . a mere withering away in decay" but the "twilight dusk."[57] "Dusk" is not only the twilight of the end, for the morning, too, has its twilight. Twilight is also rising. Thus "death" means the "going down," a downfall into the "ghostly twilight." The poet, says Heidegger, sees the soul, "something strange," as destined to follow a "path that leads not to decay, but on the contrary to a going under. This going under yields and submits to the mighty death. . . ."[58]

In Hillman's work *The Dream and the Underworld*, the imaginal psyche is "placed more definitely within a psychology of dreams and of death. . . ." Depth psychology becomes now "a bridge downward"; it must begin in the mythological underworld, i.e., "with the perspective of death."[59] However, the world of Hades is not the place of decay or literal death. Hades, the brother of Zeus, is synchronous with life: it gives to life its depth and its soul. Somewhat as in Heidegger, the end of life for Hillman is "not in time but in death"—the "ghostly twilight." Death in the imagistic and psychological sense means "the *telos* or fulfillment of anything . . . we can stop anywhere, because from the final point of view everything is an end in itself. The goal is always now." Hades is *telos* as "the unseen one and yet absolutely present."[60] Rilke has expressed the integral phenomenon of life-in-death and death-in-life in a way that should satisfy both Heidegger and Hillman.

> Death *is the* side of life *averted from us, unshone upon by us: we must try to achieve the greatest consciousness of our existence which is at home in* both unbounded realms, inexhaustibly nourished from both . . . there is neither a here nor a beyond, but the great unity *in which the beings that surpass us, the 'angels', are at home. . . . We of the here and now are not for a moment hedged in the time-world, nor confined within it;*

Play and Earth

we are incessantly flowing over and over to those who preceded us.[61]

Hillman also points out that the images in Hades are Dionysian—fertile in the psychic or imaginal sense. "There is an imagination below the earth that abounds in animal forms, that revels and makes music. There is a dance in death."[62] There is dance in death because Dionysus, the brother of Hades, is the Loosener (*Lysios*), the one who sets free, dissolves, breaks bonds and laws. Another figure that in Greek mythology symbolizes loosening (detachment) is Dionysus Zagreus, the suffering and dismembered God whose divine substance is distributed throughout the whole of nature. Hillman understands dismemberment as a psychological process involving a "bodily experience"—an experience which would result in the abandonment of "central control,"[63] i.e., the dethronement of the ego and its hegemonic position in the totality of psychic life.

According to Heidegger as well, to go down into the ghostly twilight means "to lose oneself" in the sense of loosening one's bonds and slowly slipping away. And yet, such loosening is not a literal end. "Day goes through evening into a decline that is not an end, but simply an inclination to make ready that descent by which the stranger goes under into the *beginning* of his wandering."[64] What Heidegger is saying here is that going down is also going up and that there is nothing 'abominable' about it so long as one does not hold on to an ego-centered style of consciousness. The stranger is also called by Trakl "he who is apart," a madman who *lives* in his grave. "The departed one is a man apart, a madman, because he has taken his way in another direction"; his madness, however, is "gentle," "for his mind pursues a greater stillness"; he is "the tender corpse."

The apartness of the soul, according to Heidegger, is spiritual but not as opposed to material or as *noeton* is opposed to *aistheton*. The spiritual, understood as the rational, intellectual, etc., together with its opposite, the material, "belong[s] to the

88

world view of the decaying kind of man." The spiritual apart-
ness of the soul is not primarily something pneumatic (from
pneuma) or ethereal but "a flame that inflames, startles, horrifies
and shatters us."[65]

Trakl sees spirit in terms of the original meaning of the word
"ghost"—a being who is terrified, beside himself, ex-static (Da-
sein). And yet the ghost is also gentle, "the tender corpse." The
gentleness of the spirit is due to the fact that its home, its
"groundless ground," is soul. "The soul . . . guards the spirit, so
essentially that without the soul the spirit can presumably never
be spirit. The soul 'feeds' the spirit."[66] According to the tenets of
archetypal psychology as well, our spiritual flights and en-
thusiasms, our aching for transcendence, etc., are essentially a
psychic adventure. For "all things are determined by psychic
images, including our formulations of the spirit."[67]

Heidegger is careful to emphasize, however, that the nature of
apartness or of true spirituality is yet concealed from us. Trakl
calls it the land of evening, the Occident. To Heidegger, it is not
a geographical location but the "open region that holds the
promise of a dwelling and provides a dwelling." The "Occident"
is "earlier and therefore more promising than the Platonic-
Christian land, or indeed than a land conceived in terms of the
European West."[68] It is the "first beginning," not the abyss of
death. "Apartness is the gathering through which human
nature is sheltered once again in its stiller childhood, and that
childhood in turn is sheltered in the earliness of another begin-
ning."[69]

We may get closer to an adequate grasp of these enigmatic
lines by paying attention to Heidegger's use of the words "blue"
and "blueness." The stranger who descends *ad inferos* is called
by Trakl "the lunar one; he must lose himself in the ghostly
twilight of the blue." As we mentioned earlier, to Heidegger
"blue" is not a symbol pointing to something other than itself,
in our case to holiness or the sense of the holy. "Blueness itself is
the holy, in virtue of its gathering depth which shines only as it

veils itself."[70] The descent (downfall) of the soul is therefore nothing more cataclysmic than relinquishing of the inauthentic (unimaginative) form of man, an escape from the tyranny of the commonplace and from the sin of literalism. But why does Heidegger use the word "blue"? What has "blueness" to do with the authentic form of man?

For writers on the symbolism of colors, blue stands for imagination; blue is the color of imagination and of the imaginal psyche. In this capacity it denotes "a state of mind no longer concerned with distinction between things and thought, appearance and reality."[71] Cézanne made blue "the foundation of his world of objects 'existing together. . . .' It expressed the essence of things and their abiding, inherent permanence and placed them in a position of unattainable remoteness."[72] According to Hillman, "the blue firmament is an image of cosmological reason; it is a mythical place that gives metaphorical support to metaphysical thinking. It is the presentation of metaphysics in image form."[73]

Heidegger's stranger, if he is to discover the earth and dwell poetically on it, must "lose himself in the spiritual twilight of the blue." The one who 'goes under' is not someone who has simply perished but rather one who "looks ahead into the blue of the spiritual night." The downfall of the soul is not merely "a falling into emptiness and annihilation"; it is also the arrival "at a quieter sojourn in the early morning"; the departed one has passed "into the 'golden showers' of early morning."[74] There is little doubt, in my opinion, that these evocative sentences point to the intermediate realm of imagination, the proper dwelling place of the soul. The earth to which the stranger must return is an imaginal location or what Corbin, following Sūfi and Mazdean cosmology, calls the "Celestial Earth" (the "world of Hūrqualyā").

The "Celestial Earth" is *the Earth of the soul, because it is the soul's vision.*"[75] The earth is perceived here not as a conglomera-

tion of physical facts but as a psychic event, as an angel, or as a "primordial Image."[76] The "Celestial Earth" belongs to a sacral space which does not need to be situated because it is itself *situative*. In *medio mundi* the soul is no longer bound by spatial coordinates: "Instead of . . . having to *be situated in* a predetermined space, the soul itself 'spatializes,' is always the origin of the spatial references and determines their structure."[77]

So it is to this earth, "translucent with blueness" and personified as an angel, that the soul belongs and, conversely, it is this earth that corresponds to the soul's virtual angelicity. Put differently, the substance of the soul is engendered and formed from the "Celestial Earth," and the "Celestial Earth" is created by the illumined soul. The angelic man and the Angel Earth are correlative realities: man is the creature of the earth just as the earth is a creature of man.

Corbin's "Celestial Earth" with its physics, geography, climates, and fertilities provides a new ground for the discredited metaphysics of the past—a ground in imagination which appears groundless only because we have come to understand 'ground' in a purely physical and literal sense. The "Celestial Earth" is a ground not only for our feet but for our heads ('headtrips') as well. In Hillman's estimation, Corbin has opened a radically different perspective toward grounding: "The firmament above is an archetypal, angelic ground of the mind. The mind descends from archetypal configurations; it is originally in converse with angels and has this angelic originality forever possible, so that all terrestrial and material events can be led back by an act of *ta'wil* (return) to the original ground in the white earth."[78]

Hillman has further explored Corbin's image of the "Celestial Earth" by placing it within the context of alchemy. In the alchemical opus, gold, which represents spirit (sun), is always preceded by silver, metal of the moon and the seed of the moon in the earth. To the alchemists the earth is not made of dead

matter to be pushed around, for its metals are nothing less than solidified planetary spirits; they are the stabilizing agencies of the earth analogous to Heidegger's Gods (the immortals of the foursome) who are by definition Gods of the earth. This reminds us, says Hillman, that "the Gods are within the world, buried in the depths of earthly affairs, under our feet as we walk. We walk on their heads and shoulders, they hold us up, though we may suppose them placed into heavenly orbit by our human fantasies."[79]

The truth of silver is located in the "lunar mind" which is "the prior ground" of gold (spirit).[80] Silver involves us in aesthetic refinement, and the seemingly cool and unrelated silver psyche is capable of establishing connections that are foreign to the calculating reason: "it mediates . . . by means of its own detachment."[81] The silvery psyche is like a mirror—both receptive (moist) and solid. It possesses "solid receptivity" that requires focusing, active attention. The kind of thinking proper to the psyche is based on precise argumentation (but is not 'argumentative'). The word "argument" comes from the same root as *argentum* (Greek *arguros*) 'silver.' A true argument would make something shining, white, focused, for "we cannot image without being precise, and what is not precise, not limited, not focused is not an image."[82]

Hillman distinguishes between two sorts of "white": the immaculate, innocent, unsullied white from which anything earthly is absent and the alchemical white (*albedo*) which emerges from black (*nigredo*) symbolizing depression, corruption, stench, etc. *Albedo* is the white (celestial) earth, innocence regained though not in its pristine form. "Here, innocence is not mere or sheer inexperience, but rather that condition where one is not identified with experience": it is a release (*nir-vana*) "from the nigredo of personal identity into the mirrors of impersonal reflections."[83]

The White Earth is the middle realm of the soul, a state of betweenness which is indifferent to all abstractly established op-

posites, a state of holiness or, as Christian mystics called it, "holy indifference." One may characterize it also as a condition in which my emotions, thoughts, etc., cease to be 'mine' and are experienced as something 'outer' or 'other.' At the same time, however, things in the so-called outer world are interiorized. In the last resort, therefore, it hardly matters where we turn in our efforts at self-actualization, to things (the world) or to the psyche. Within the parameters of the "Celestial Earth," things are images and images things. In a rare reference to Heidegger, Hillman writes: "Things themselves are becoming psychic; the psyche's thingness, and its thinking (Heidegger), are beginning to show reflection: things as images, images things; the *dinglichkeit* of psychic phenomena."[84]

Heidegger said that the "land of evening" (Occident) is really "another beginning." In Hillman's terms it would be the land of second innocence, the White Earth or the "lunar ground," which he also calls a "place of truth." Like Heidegger's *aletheia*, the place of Hillman's 'truth' is neither up nor down, neither in spirit and things spiritual nor in matter and things material; rather, it is oriented eastward, "toward the Orient, dawn's early light, glimmer of silver. . . ." Precisely. *Aletheia* is on the moon or, for that matter, on "this earth . . . whitened by a mind which perceives whitely, metaphorically."[85] A walk on the moon is, therefore, not different from a walk on the earth on the condition that we walk as lunatics or that we dwell poetically wherever we happen to be.

As I have occasionally pointed out, the affinity between the late Heidegger and Hillman is most clearly seen in their rejection of subjectivism. The crucial question, then, will be: What, if anything, can be substituted for the discarded subjectivism and its twin brother, objectivism? If images are things and things images—who is imaging what? "What is reflection . . . when there is no subject reflected, neither emotion nor external object? No fact at all?"[86]

Hillman's answer is that mental events, when they are not

divorced from imagination, that is, *mental events as images*, need not be validated either by reference to external facts or internal happenings (my having a dream, thinking an idea, or feeling an experience). As we have insisted on several occasions, images, like the soul itself, are self-referential. We can have soul and imagination without subjectivity, be it conscious or unconscious, empirical or transcendental, personal or transpersonal.

When Jung, during his travels in Africa, witnessed animal herds like slow rivers across the primeval scene of Athi Plains, he exclaimed: "Man, I, in an invisible act of creation put the stamp of perfection on the world by giving it objective existence."[87] Clearly, Heidegger would see in these words yet another confirmation that Jung, in spite of his epochal discoveries in the realm of psyche, was unable to discard all vestiges of subjectivism. To Hillman, as it would be to Heidegger as well, the witnessing "I," putting "the stamp of perfection" on the world or giving it objective existence, is unnecessary. The objective world does not require a human subject or consciousness, for both "I" and the herds of animals are images. "Consciousness may be necessary to the *anima mundi* in specific ways she devises, but consciousness is not confined to my mind. . . . The plains are, and their grazing gazelle, and these images move in the soul of the world unwitting of 'Man, I' or any personal observation. . . . Take joy in witness, but do not believe the world is held together thereby." What Hillman is doing in this magisterial passage is to move beyond all philosophies that place imagination in the mind and consider the soul as a conglomerate of subjective functions. The mind is in imagination just as 'my' soul is in *anima mundi*. What is left and what more can we say? Only this: "The event is there, shining. . . . Let events belong to themselves . . . the event is the mirror self-sustaining its own reflection. Have faith in the everlasting indestructible ground of images. They do not need us."[88]

Hillman is describing, in the language of archetypal psychology, what Heidegger calls the Event of Appropriation—a "sheer

occurrence without reference to a thing occurring."[89] The shining event is also the inscrutable Play that is neither subjective nor objective but belongs to itself. Like Angelus Silesius's Rose, it needs no internal or external justification (grounding) because both the internal and external are grounded in imagination, in "the everlasting indestructible ground of images." Hence, when Hillman says that images do not need us, what he means is that images do not require confirmation on the part of our subjective ego. The ego's function is precisely to distort the image by not letting it shine in its own ground. If, however, images do not need us in this sense, *we* do need images. Images, like myth, are necessary for the enchantment of the soul, said Plato. There is nothing more ultimate than that—enchantment, eternal delight in coming and going, in ascending and descending on Jacob's ladder. The Event events. Imagination imagines.

VI

Releasement

Throughout these pages I have frequently used expressions like "letting-be," "paying attention," "gathered attention," "noticing." I have not tried to tie all these words together into a single theme, for the context in which they appeared made them, to some extent, self-explanatory. There is, however, one word in Heidegger's later writings which, in my opinion, not only typifies and summarizes the quintessential Heidegger but also can be taken as a kind of moving force behind Hillman's poetizing thought. The word is *Gelassenheit*, usually translated as releasement, serenity, self-resignation, letting-be. For Heidegger, *Gelassenheit* has a more specific meaning; it has to do with a willing renunciation of willing or with something in the order of T. S. Eliot's "Teach me to care and not to care." Hillman, besides his emphasis on attentive noticing, speaks of "the coolness of the image" and "the cool detachment by which we see through to the image."[1]

My intention in this chapter is to show that the gnosis of Hillman and Heidegger culminates in a therapeutic sort of injunction to pay attention to things (images) so as to let them be what they are. *Being appears* ("essentiates as appearing") *through "letting-be."* In Hillman's works we have only scattered remarks on what would be the equivalent of Heidegger's "releasement"

to which the latter has devoted a separate essay.[2] However, from the point of view of archetypal psychology, it is unnecessary to deal explicitly with this question for the simple reason that "true imagination" (Paracelsus) is by itself and of itself inseparable from the exercise of attention. In other words, images acquire the characteristics of autonomy, self-referentiality, and simultaneity only when they are watched in a detached way, i.e., without being filtered through the distorting lens of the imperial ego. There has to be a certain amount of selflessness and self-abandonment in every act of true imagining. Indeed, the whole import of archetypal psychology and its relevance for contemporary man lies in the fact that it provides a new and yet very ancient way of being "religious"—a way of knowledge and thinking that is also a way of being-in-the-world. Put differently, images, released into their "just-so-isness," tell their own story, become knowing, intelligent, wise. But this knowledge and intelligence are no longer simply "mine"; rather, they are received as a gift. Thinking becomes thanking for the gift of Being, for the "sheer occurrence" of things, for the Event.

Heidegger's idea of *Gelassenheit* is adumbrated in Jung's practice of giving attention to the *manifest* content of dream images (in contrast to the Freudian approach which saw the *latent* content of the dream as the meaningful portion). In the process of what Jung calls "active imagination,"[3] one looks at the images emerging from the unconscious in a particular way:

> . . . looking, *psychologically, brings about the activation of the object; it is as if something is emanating from one's spiritual eye that evokes or activates the object of one's vision. The English verb, to look at, does not convey this meaning, but the German* betrachten . . . *means also to make pregnant, but it is used only for animals. . . . So to look or concentrate upon a thing,* betrachten, *gives the quality of being pregnant to the object. And if it is pregnant, then something is due to come out of it; it is alive, it produces, it multiplies itself.*[4]

Releasement

The capacity to register and allow things to be what they are is also likened by Jung to the Taoist (and Meister Eckhart's) precept of "doing by not doing" or "action through non-action" (*wei wu wei*). Non-action, which here means not passivity but a dynamic and highly alert attentiveness, is designed to prevent the practitioner of active imagination from becoming entangled in the materiality or the content of the image. Mary Watkins has explained the Jungian approach in these words:

> Trying to watch our psycho-mental flux without interfering in it or becoming attached to its contents (and thereby losing awareness) and yet to still be receptive to it, is one of the hardest possible things—perhaps because of the paradox of activity embodied in the principle of action through non-action. We must sacrifice what seems to us a sense of control on our part. . . .[5]

The Taoist non-action is similar to that of a child who tells you that he is doing nothing while deeply immersed in a game. He is doing nothing because he has no particular purpose in mind, exerts no effort, bothers no one. In the final analysis, he is doing nothing precisely because it is the game itself that does everything. As the *Tao Teh Ching* (chap. 37) has it: "Constantly, Tao does nothing, yet does everything." Action through non-action is a movement without purpose and without a 'why'; it is atelic and anarchic.

Similarly, there is a moment in the Jungian–Hillmanian *therapeia* when images are experienced as independent of the control of ego, when they "come and go (as in dreams) at their own will, with their own rhythm, within their own fields of relations, undetermined by personal psychodynamics."[6] There is a moment, in other words, when the Play "does everything." This, however, is far from saying that the Play is something utterly irrational making us, as individuals, mere marionettes. The autonomy of images is not automatic; autonomy is not automatism. What is required on our part is nothing less than active attention, a willing renunciation of willing, *Gelassenheit*.

Releasement

The word *Gelassenheit* is from the Old German *gelâzenheit*, and the infinitive *lâzen, lassen* signifies "to let" or to "let be," "to untie"; it denotes a human attitude that accepts things and events not in terms of their usefulness but of their autonomy. As such it must be carefully distinguished from the Stoic *apatheia* which involves constant effort of moral will; there is nothing voluntaristic about Heidegger's *Gelassenheit*. For the same reason, he wants to think of it, not within the realm of morality, but in relation to meditative thinking. Heidegger is interested in overcoming subjectivism, not sinful selfishness or the like. The real perversion consists in the refusal to acknowledge the priority of Being and in subordinating everything to the dictates of the subject. Sub-jectivism is the desire on the part of reason to impose its own categories on things, to legislate the way things must be. The entire history of Western metaphysics is a history of rational prescriptions about what Being must be (*eidos, ousia, Gegenstand, Geist*, etc.).[7]

The difficulty with Heidegger's notion of *Gelassenheit* is that it advocates a willful renunciation of willing: we have to be will-less, but we cannot will to be will-less. The apparent contradiction can be resolved only by replacing representational thinking with meditative thinking which results in releasement (*Gelassenheit*). For example, when one says "I let it be," something is set free, a grip is loosened, and the eye, instead of staring at an object, begins to see through the object. A thing, freed into the truth of its being, is seen for what it is, i.e., as an image that stands on its own needing no external support, no exterior why; it is because it is. In this sense, the attitude of letting-be, far from suggesting carelessness or lassitude, is the highest form of care, a *therapeia* that is not confined to the individual human soul but includes caring for all things.

According to Heidegger, then, the truth (*aletheia*) of Being or things can never happen without a collaboration of man—the shepherd of Being. As Schürmann says, "the happening of truth

is never unconditioned. Its condition is releasement. . . . When the peasant shoes are 'let loose,' or released from, their usefulness and reliability, their truth—thingness—occurs. Releasement is the attitude that makes possible truth's coming into presence. . . . Releasement manifests the thing's way to be."[8]

It should be clear at this point that it is not quite enough to say, as we did, that phenomenology begins on the subtle level. We must now add that the subtle level—the level of the ensouled phenomena (and by the same token the conversion of phenomenology into angelology)—is inseparable from the practice of releasement. We see subtly (imaginatively) only when we ourselves have become subtle. Subtle seeing is gnosis—a way of knowing which is also a way of being. Gnostic seeing is predicated, in Smith's words, on the necessity to "realign the components of the soul in ways that would enable it to experience the world in an *un*ordinary way—a way so *extra*ordinary, in fact, that from its perspective passion-and-ignorance-laden ordinary experience would seem almost psychotic."[9] There is also Wittgenstein's famous assertion: "The philosopher's treatment . . . is like the treatment of an illness. . . . Sickness . . . is cured by an alteration in the mode of life of human beings. . . ."[10]

What Smith calls an "*un*ordinary" way of experiencing the world is in reality the same as that condition, referred to by Hillman, in which "one is not identified with experience." It is a "second innocence," the whiteness (*albedo*) that emerges from blackness (*nigredo*). In Christian mysticism it is known as "purity of heart" or "purity of attention" which, on the philosophical plane, corresponds to the "passive or receptive intellect" of Aristotle. In Meister Eckhart's mystical thought, the receptive intellect is depicted as virgin, that is, virgin of all images, for to be attached to images as to a property renders the mind stupefied, dull, and almost psychotic. It is important to stress that Eckhart and the representatives of the *via negativa* in general are not opposed to images *tout court* but to an avid attachment to

images and representations, i.e., the entanglement in the materiality (content) of images. According to Schürmann's interpretation, however, Eckhart is not satisfied with his first step in the mystic's journey toward the abyss of the Godhead: the receptive side of detachment—the virgin—must be completed by the active side or the "active intellect" whose biblical figure is "wife." In the last analysis, Eckhart "deems the activity that completes detachment superior to passive reception [fancy]. . . . 'Wife' . . . is the noblest name that can be given to the mind, and it is much more noble than 'virgin.'"[11] The compound "virgin-wife" is equivalent to active attention or to a receptivity that is fertile in its emptiness, a waiting that is open to the gift of Being.

Thus there is no Being and no truth without releasement, which is the same as saying that one cannot arrive at truth without exercising active attention or, in Eckhart's terms, without being simultaneously virgin and wife. We are facing here the deepest paradox of human existence exhibited by the saints and sages of all religions: "an extraordinary, passionate involvement in the whole life of man together with a luminous detachment from it, a profound outward movement coexisting with an equally profound inward movement."[12]

Releasement is detached involvement. In Heidegger's words, *Gelassenheit* "is in no way a matter of weakly allowing things to slide and drift along. . . . Perhaps a higher acting is concealed in releasement than is found in all the actions within the world and in the machinations of all mankind."[13] What is this "higher activity"? It is "waiting" in the sense of "doing by not doing." Releasement is not an object or goal to be striven for, and there is nothing we can do to accomplish it or to accelerate its arrival. Our "doing" must consist in undoing the accumulated traces of past deeds (karma), that is, in waiting. We wait, however, not passively but as saints and animals wait—in prolonged alertness to the unknown, the strange, the wonder. Releasement is a suspension of all teleological attitudes accompanied by openness

Releasement

to the mystery of the Play. It happens neither in 'me' nor in the world of objects but in that emptiness which is also an "invisible fullness" and which Jung called *esse in anima*. The point is to persevere in emptiness, to live without Why.

VII

While the Music Lasts

1. Personified Cosmos

The single most important conclusion to be drawn from our examination of gnosis in Heidegger and Hillman is that it leaves the door open to the inauguration of a new metaphysics centered around the notion of a personified cosmos. My aim in this chapter is, first, to provide rudiments for such metaphysics by amplifying the call "back to the images themselves" into a call "back to the mundus imaginalis"; second, to show that the conception of a personified cosmos results in something like mystical polytheism.

In a recent paper Hillman acknowledges—somewhat ruefully—that his method of "seeing through" (psychologizing), though necessary, is not sufficient. Psychology must begin to "meet the soul's concerns about the nature of the cosmos in which it finds itself. The smallest Freudian child asks Aristotelian questions about coming-to-be and passing-away. Soul seeks to understand itself beyond itself."[1] To satisfy these needs, he proposes "psychological metaphysics" which, of necessity, must be placed in "imaginal locations,"[2] i.e., in the mundus imaginalis.

As already explained, the essential function of Corbin's imaginal world is that of a mediatrix—to mediate between the physical and the spiritual. The faculty of perception peculiar to

this world is visionary imagination whose proper place is "the place of visions, the scene on which visionary events . . . *appear* in their true reality." It is "an intermediate world . . . of archetypal figures, of subtle substances, of 'immaterial matter' . . . 'where the spiritual takes body and the body becomes spiritual'. . . ."[3] The fundamental characteristic of the visionary imagination is to effect a complete and instantaneous realization of the imagined contents. This is to say that images are perceived here as a *Gestalt*, all parts simultaneously, wholeness or unity together with the face of each thing and event.[4] In Heidegger's terms, things and events are essentified in their appearances. In contrast to our ordinary experience, appearances in the *mundus imaginalis* are not deceptive. The style is the man.

According to Corbin, imagination on the visionary plane "posits real being."[5] In a modified version, suggested by Casey, "real being" is "real *imaginal* being."[6] It is also important to emphasize that visionary imagination is potentially present at *every* level of human experience as, for example, in the case of Blake and Raine.[7] I am including, therefore, under the rubric "*mundus imaginalis*" not only the visions of Corbin's Islamic Sufis but also things seen in the Beyond by men like Blake and the Swedish visionary Emanuel Swedenborg.

The basic feature of things and beings in the imaginal world is that their outer manifestations correspond to their innermost spiritual structures. Each man is inside his own paradise or, alternatively, inside his own hell: "'The paradise of the faithful gnostic is his very *body* and the hell of the man without . . . knowledge is likewise his body itself.'"[8] Unlike the universal and immaterial ideas of Plato, the beings of the imaginal world are experienced by Sufi meditators as "*particular* forms [specific individualities] that are separate from Matter, but by no means from all material . . . envelopes."[9] They are personal presences, individual and unique, having a corporeality

and spatiality of their own, an immaterial materiality or what the Cambridge Platonist Henry More called *spissitudo spiritualis*—a kind of spiritual extendedness.

The gnoseological meaning of these permutations is that the perception of all reality in the imaginal world is reduced to the perception or visualization of a concrete person: "Everything takes place as though the question 'Who is it?' were substituted for the question, 'What is it?'—as though to name the *person* were to define its *essence*."[10] Corbin calls this "procedure" *reductio ad modum angelicum* or angelomorphosis in that the question asked by the gnostic is not about the essence of things but about their personality, as, for example, *who* is the Earth, *who* are the waters, the plants, the mountains. In the words of the Iranian theosopher Nasiraddin Tūsī, "Paradise is a *person* (or a human being)." "Every thought, every true word, every good action *has* an Angel."[11] Around these and similar propositions Tūsī develops a phenomenology which is also gnosis: "To be in Paradise" or "to come into this world" are different modes of understanding corresponding to different modes of being. The expression "to come into this world" designates a merely metaphorical existence whose meaning consists in leading the empirical man to his true being, the external and exoteric (*zahir*) back to the internal and esoteric (*bātin*). For even while one is materially present in this world, there is a mode of being in paradise (*mundus imaginalis*). But the paradisiacal mode of being can be realized "only in a person who precisely *is* this Paradise—that is to say, who personifies this mode of being." Fundamentally, therefore, it can be said that "the reality of the act, of the event, is . . . reduced to the person who enacts it."[12] Every action, thought, or word has its term in the angel. The ego-personality is an agent only in a superficial and metaphorical sense; more active than "I" is the thought that is thought through me, the word that is spoken through me. As Tūsī says: "In thinking this thought the person who thinks it is

thought by the Angel, or, on the contrary by a demon, for the alternative can only be the person 'without an Angel'."[13]

The personified cosmos, such as we find it in the Iranian gnosis, is in many respects similar to Swedenborg's vision of the Beyond. According to Swedenborg's teachings, the appearances of things in heaven are plastic to the states of mind of the spirits. The spirits are not "fixed and dead" but, like images, ever-changing and polymorphous. Yeats describes these heavenly permutations as follows: "So heaven and hell are built always anew and in hell or heaven . . . all are surrounded by scenes and circumstances which are the expression of their natures and the creation of their thought."[14] In Swedenborg's own words:

> All spirits in the hells . . . appear in the form of their evil; for everyone there is an image of his evil, since his interiors and his exteriors act as a one, the interiors making themselves visible in the exteriors, which are the face, body, speech and movements; thus the character of the spirit is known as soon as he is seen.[15]

The same principle applies to heavenly states: the heaven of angels (who are realized men and women) is not separate from their private being. In general terms, the other world corresponds to or symbolizes the creative imagination. We all create and eventually join the world of our own choices. In this sense life in the Beyond offers no surprises: it is nothing more nor less than an essentification of our real selves or, in Swedenborg's terminology, of our "ruling love," for the love (Eros) of man is his very life and, as is the love, so is the life. In Heidegger's terms: Being 'essentiates' as appearing.

Swedenborg's correspondences between natural and spiritual things are an extension of the alchemical doctrine of signatures. Both of these principles are based on the gnostic idea that being and thought, existence and meaning are inseparable. For Swedenborg (and Blake) knowledge is not something abstract, impersonal, or objective but a mode of being isomorphic to the

knower. Contrary to the dominant Western view, extending from Plato and Aristotle to Averröes and Aquinas and culminating in Descartes, the knower is not divorced from the known, the inner from the outer, the self from the world. We are able to know the so-called outside world only because something of that outside world (*anima mundi*) is also inside ourselves. In theological language this would imply that God (or cosmos) is knowable, but we cannot know him until we become similar to him.

Swedenborg also repeatedly stresses that "God is very man."[16] When Blake annotated Swedenborg's *Wisdom of Angels Concerning Divine Love and Divine Wisdom* in 1788, he noted such passages as "In all the Heavens there is no other Idea of God than that of a man." The Swedenborgian Man, however, is not the natural or empirical man but a divine body who is neither large nor small nor of any dimension. To paraphrase Casey, he is a "real *imaginal* body" or a real apparition. For what Plato and Blake sometimes called "true man" is not a species of the genus "animal," not a rational animal at all, but a kingdom (Eden in Blake) or a microcosm who participates in all strata of the universe—mineral, plant, animal, human, and spiritual. In a letter to his friend Thomas Butts, Blake has poetized the Swedenborgian vision of an animated universe in which each particle of light and each grain of sand is perceived as "Men seen Afar": "Each grain of Sand,/Every Stone on the Land,/Each rock & hill,/Each fountain & rill,/Each herb & tree,/Mountain, hill, earth & sea,/Cloud, Meteor & Star,/Are Men Seen Afar."[17]

Swedenborg teaches that all natural particles are human—formed as a result of heaven's being "in its greatest and least parts like itself." The physical frame of the universe is comprehended within the body of the Grand Man (*Homo Maximus*): all is human. Raine has noted that the influence of this Swedenborgian vision "is to be seen on almost every page of Blake's designs, where animate human figures spring to life at every

touch of calligraphy, from tendril and spray. Tiny insects, cater-
pillars, midges, moths, and ants become 'Men Seen Afar'
because all are in truth living cells within the greater organism
of the Grand Man."[18] Raine summarizes this extraordinary vi-
sion of things in the following sentence: "Every face in the
world is one of the numberless faces of the Divine Human."[19]

We may gain a better grasp of what is at stake in Raine's state-
ment by relating it to Sūfi mysticism which speaks of the iden-
tity of man with the August Face of God. The Sūfis, like most
mystics, maintain that we do not see God in his essence—the
deitas abscondita of negative theology—and to that extent he is
unknowable, unapproachable, etc. According to Corbin,
however, Sūfism qualifies this by saying that we do not see Him
in the same way we do not see the mirror when we contemplate
an object in it.

> *When you contemplate a form in it, you do not see the mirror,
> though you know perfectly well that you see forms and your own
> form only in this mirror; you cannot at the same time look at the
> image which appears in the mirror and at the body of the mirror
> itself. . . . God . . . is your mirror, that is, the mirror in which
> you contemplate your Self (nafs, anima), and you, you are His
> mirror, that is, the mirror in which He contemplates His divine
> Names.*[20]

There is a relationship of reciprocity—Corbin calls it "dialogal
situation"—between the mystic and his God. In other words, "it
is essential to the infinite Godhead to manifest itself in this or
that finite form. The Godhead *is* this Form, and this Form is all
this and nothing more: apparition."[21] The Sufi mirror-like vi-
sion is really the same as the ability, mentioned earlier, to see
the light "everywhere." There is no unique and irreplaceable
center in which light is concentrated and toward which one
would have to adopt the position of an onlooker. We do not
have to position ourselves to see the light precisely because it is

everywhere and can be seen from every position. Every face in the world is a unique center/concentration of the whole. Needleman has expressed a similar view in more general terms: "The greatest vision of a reality beyond the appearance of this world is associated with a pure and exact awareness of those very appearances."[22]

The idea of mutual co-inherence or co-origination of the divine and the human is an essential part of the German mystical tradition of Meister Eckhart, John Tauler, and the *Theologia Germanica*. Angelus Silesius has summarized it in the epigrammatic lines: "I know that God cannot live one instant without me;/Were I to become nothing, He must give up the ghost."[23]

Not surprisingly, we find the same thought in Jung's mystical forays. In his *Septem Sermones ad Mortuos*, the Seventh Sermon defines God as a star which glimmers in immeasurable distance above and at the same time represents the individual's soul: "To this one god man shall pray. Prayer increases the light of the Star. It casteth a bridge over death. It prepareth life for the smaller world [microcosm] and assuageth the hopeless desires of the greater [macrocosm]."[24] God's dependence on man and man's dependence on God are expressed even more clearly in one of his letters: "God wants to be born in the flame of man's consciousness. . . . One must be able to suffer God. . . . He must be the advocate of the earth. . . . God needs man in order to become conscious, just as he needs limitations in time and space. Let us therefore be for him limitation in time and space, an earthly tabernacle."[25]

Jung's pronouncements should be seen against the background of his understanding of mandala symbolism. In *Psychology and Alchemy*, he states that the quaternity symbol of the mandala indicates the "God within" the psyche. But he also notes that the mandalas drawn by contemporary persons almost never contain a God-image in the center of the design, as

might have been the case in earlier periods: "There is no deity in the mandala, nor is there any submission or reconciliation to a deity. The place of the deity seems to be taken by the wholeness of man."[26]

If we now take the "wholeness of man" as referring to something like the Grand Man of Swedenborg, it would follow that his being at the center of mandalas means the same as being everywhere. For the mandala in Eastern religions, especially in Tantric Buddhism, is a "centerless center" expressing the experience of interpenetration of all things. In Blakean terms, the "Human Form Divine" is dispersed throughout the entire range of being.

Jung, however, is ambiguous in his understanding of the Eastern mandala. At least on one occasion, he has characterized it as "the premonition of a centre of personality, a kind of central point within the psyche, to which everything is related."[27] In common with the mainstream of Western psychology and philosophy, Jung could not conceive of a consciousness without a *permanent* center (ego) and preferred to see the mandala as pointing from the ego to a larger Self as the true center of personality. Inevitably, Heidegger would detect in this move a disguised subjectivism (perhaps similar to Kant's transcendental subjectivism) that can only exacerbate the escalating oblivion of Being. That something of the sort is indeed at work in Jungian psychology is shown by the alacrity with which orthodox Jungians have been able to identify the Self with a monotheistic deity (Yahweh) or the Christ of the official Christianity.

The Jungian Self, Heidegger would suggest, is nothing more than a psychological version of the Thomistic God, modeled on the Roman notion of *actualitas* which replaced the Greek *physis*. Romans, the builders of roads and empires, conceived Being in terms of activity and action (*agere, actio, actus*), of doing, making, producing. The Medievals adopted this Romanization of the Greek experience of Being by defining God as the most fully

actual being, the *actus purus*. To add to this Being the epithet "creator" is not an improvement. On the contrary, by sharply distinguishing between uncreated Creator (the unproducible producer) and his creation (product), Thomism propounds a metaphysics of power not far removed from the Nietzschean will-to-power which to Heidegger represents the ultimate stage in the forgetfulness of Being. God is now seen as a carpenter who manufactures the world, not as an artist who brings something to the light of day. In Hillman's words, he is law-giver and scientist who "works through numbers and laws" in contrast to a God who is "the artist who works in images," "God as image-maker."[28]

Heidegger's main objection to the traditional image of God is that he is conceived as "light through and through," a "pure and perfect presence, a perfect upsurge into Being . . . in which there is no prior, concomitant, or subsequent concealment. . . ." Somewhat like the fully realized Jungian Self, he is "an unlimited act of knowing united perfectly to an unlimitedly perfect being."[29] In Western onto-theology, the original presencing (*Anwesen*) process, experienced by the Early Greeks as the rising up into appearance, has stiffened into an understanding of Being as objective or "permanent presence" (*ständige Anwesenheit*). Being (*physis*) became *one* being which "persists and perseveres at the expense of other beings. . . ."[30] In the modern epoch, Being becomes stuff at the disposal of technological man, a standing stock (*Bestand*) of stuff to be calculated and manipulated.[31] For the modern man, Being is literally technology and technological "progress."

There is no evidence, to my knowledge, that Heidegger has cut pages in Swedenborg and Blake; if he had, he would have discovered that his notion of presencing (*physis*) bears uncanny resemblance to Swedenborg's visionary spaces as well as to the visionary geography of Corbin's *mundus imaginalis*. Equally surprising—abstracting from the fact that Swedenborg's and

Blake's *Sitz im Leben* is Christianity, even if of a highly unorthodox kind—is the parallelism between Heidegger's talk about the solidification of Being in the history of Western metaphysics and Swedenborg's/Blake's description of the world and humanity after "the Fall."

Both Blake and Swedenborg conceive "the Fall" as an externalization, a turning away from a state of being in which inner and outer (soul and body) exist in a dynamic and reciprocal relationship. As a result, the body undergoes a process of rigidification which is completed in the immobility of the corpse. In certain of Blake's drawings the Fall—the descent into the pit—is headlong; in Swedenborg, too, man falls with his head down. One of Blake's frequent descriptions of the fallen state is in terms of "deadly sleep." The state of sleep is accompanied by forgetfulness which overcomes the souls who drink the waters of *Lethe* as they approach birth. Raine has observed that for Blake, as for Plotinus and the Platonists, the Fall of man is not into sin but into oblivion or sleep, i.e., spiritual forgetfulness. Consequently, "Blake's call is never to repentance but to awakening: enlightenment, not repentance, was for him the way to know God."[32]

Curiously enough, Heidegger too speaks of awakening (*Erwachen*), not, however, from oblivion since the latter can never be completely eliminated, but *to* oblivion: "Awakening . . . must be understood . . . not as an extinguishing of the oblivion of Being, but [as] placing oneself in it and standing within it."[33] Whether or not Heidegger's stepping out of metaphysics heralds such an awakening to oblivion *as* oblivion is, in the present context, of secondary importance. What is significant is that awakening or enlightenment does not annul darkness. Like the saint who is the first to know that he is a sinner, the awakened individual is the one who becomes *attentive* to his predicament. Attention breaks the spell; it dispels, as Blake would have it, the state of sleep and unconsciousness, i.e.,

a life of mechanical responses to subjective as well as objective events and experiences.

The sleeping man is said by Blake to be the "limit of opacity," immersed in degraded and alienated matter:

> "In pain he sighs, in pain he labours in his universe, /"Screaming in birds over the deep & howling in the wolf /"Over the slain, & moaning in the cattle, and in the winds . . ./"And in the cries of birth & in the groans of death his voice /"Is heard throughout the Universe: wherever a grass grows /"Or a leaf buds, The Eternal Man is seen, is heard, is felt, /"And all his sorrows, till he reassumes his ancient bliss."[34]

Swedenborg, in his own matter-of-fact style, describes the fixity of perverted nature as follows.

> . . . [the] lowest things of nature which form the lands are dead, and are not changeable and varying according to the states of affections and thoughts, as in the spiritual world, but unchangeable and fixed. . . . There are such things, because creation has there terminated, and abides at rest. From this it is evident that spaces are a property of nature; and because in nature spaces are not appearances of spaces according to states of life, as they are in the spiritual world, they also may be called dead.[35]

What are we to say of this bringing-together of Heidegger and the imaginal world? *Prima facie* the concept of a personified cosmos, as it appears in the writings of Corbin, Blake, and Swedenborg, may seem to be incompatible with the allegedly this-worldly meditations of a Heidegger. Specifically, is there a place in his thought for "the divine"? I would like to suggest—tentatively, of course—that there are hints in Heidegger's production which do lend themselves to an interpretation in the sense of mystical polytheism. Even more, the late Heidegger, in my opinion, would remain largely incomprehensible or, at best, hanging in the air, without the infusion of a substantial

dose of Corbinian–Hillmanian mysticism. Naturally, all depends on the meaning one attaches to the words "mysticism" and "mystical" and, in particular, on the relationship that may or may not exist between Heidegger's so-called mysticism and the mystical polytheism I think I detect lurking in archetypal psychology.

2. Mystical Polytheism

Heidegger rejects the classical mysticism exemplified in the Plotinian system as a "mere antitype" of metaphysics.[36] Mystical irrationalism cannot be an alternative to philosophical rationalism, for they are twin brothers, the one being the inverse side of the other. "Philosophy as a rationalist enterprise, divorced from life, is powerless; mysticism as an irrationalistic experience is futile."[37] More importantly, Plotinian mysticism for Heidegger is metaphysical because it moves within the distinction between time and eternity. Time is at best an image of eternity: eternity is the permanent now (nunc stans), time is the moving now (nunc movens). The aim of the individual soul is to melt away the edges of things and to be dissolved in the timeless and spaceless unity of the divine. Heidegger would probably agree with Nietzsche who describes this type of experience as "a narcotic state of disgust with oneself," a "voluptuous enjoyment of eternal emptiness."[38]

The mystical models closest to Heidegger's own meditative style of thought are Meister Eckhart of Hochheim (1261–1327) and the poet Angelus Silesius with his leap beyond Leibniz's Principle of Sufficient Reason. The kind of thinking we find in these two men is neither rationalistic nor irrationalistic but belongs to a sphere which is prior to the distinction between reason and unreason. We have a hint of what Heidegger means by genuine mysticism in his identification of movement (as opposed to agitation) with stillness and rest.[39] The rest is not the

absence of motion but the "confluence of all motions."[40] What Heidegger seems to be saying is that eternity (rest, *deitas abscondita*, etc.) and time, as in Corbin, coinhere in each other or that eternity must be inclusive of time. Possibly the best illustration of this is found in Heraclitus's dictum that "You cannot step twice into the same river" (fr. 21, Wheelwright). Heraclitus, it seems, is pointing not only to change or lack of identity between successive moments of our experience but also to a kind of permanence within the flux. The river preserves its form (image) while all the individual matter (the flowing water) has been replaced. However, the identity of the river remains fixed, not in spite of the fact that its waters are constantly changing, but precisely *because* they are changing. The difference between "in spite" and "because" is decisive. In the first case, we would be faced with a situation in which change is posited as something illusory and hence not affecting in any essential way the substance of the river. In the second case, change is seen as constituting the very essence of the river. The river is at rest (or, as Heidegger would have it, engaged in "higher activity") because it changes.

The Heraclitean relationship between the river and the flowing water is analogous to the relationship that, in Heidegger as well as in Eckhart, exists between Being (Godhead, *deitas abscondita*) and man.[41] Neither of these two thinkers, however, speaks of "man" as the word is commonly understood. As Caputo puts it, "there is something deeper within man, something which is not merely human, which constitutes man's true dignity and worth . . . there is a hidden ground in which man's truest being and essential nature (*Wesen*) lies."[42] According to Eckhart, the "hidden ground" of man which constitutes his true humanness is the "little spark" of the soul, the place in which God and the soul meet. In a similar fashion, Heidegger asserts that "the profound source of man . . . belongs to the way to be of Being and is needed by it in order to uphold the way to be of

Being in its truth."[43] Both Heidegger and Eckhart reject the zoo-
logical conception of man as an animal with the specific differ-
ence of rationality, spirituality, or personality. All determina-
tions of this kind envision man as belonging to a species of
beings which must be differentiated from other species, that is,
as an unchanging substance moving along the stream of life.
The ground of the soul is not a being, or a kind of being, but a
place, or better, an empty space waiting for the advent of Being.
The "profound source of man" is purely and simply to be a rela-
tion to Being itself. The relation is not something added on to
man but the whole man. Analogously, the "little spark" of the
soul in Eckhart is not to be thought as the distinguishing mark
of the soul, for it signifies precisely that realm of the soul where
there are no distinguishing marks of any kind. The ground of
the soul is not a thing (substance) but a pure relationship to
God. The very being of the soul, according to Eckhart, consists
in providing the "birth place" for the Son just as in Heidegger
the very being of Dasein is to be the place of truth, the clearing
in which the Event of Appropriation (*Ereignis*) comes to pass.
"The very being of the Father is to give birth, and the very
being of the Son is to be born. Neither Father nor Son subsists
apart from their relation to one another. They subsist *in* this
relation; they *are* this relation."[44]

The paramount question, however, remains: How are we to
understand the identity between God and the soul? According
to Schürmann, Eckhart never speaks of *substantial* or simple
identity; rather, he teaches "the imperative of an identity to be
accomplished."[45] Eckhart's type of thought is "imperative" as
distinguished from "indicative." "Imperative thought and in-
dicative thought differ from each other in their understanding
of being: according to the first, being is known when a concrete
existence assumes the path of detachment, which is the condi-
tion and the sole content at the same time of its understanding;
according to the second, being is represented as the totality of

objects comprehended by the mind."[46] The imperative thought is concerned with "operative identity" or "energetic identity" which appears in Heidegger's understanding of Being as Event. As an illustration, we may think, says Schürmann, of what happens in music when the hearer is "all ears." If the hearer, for various reasons, fails to "reproduce inwardly" the sounds that his senses perceive, then he does not know how to listen. "Perfect listening implies that the distinction between the soloist . . . and the listener . . . is no longer true. Through the unique event of the song which enraptures us, one identical being accomplishes itself."[47]

The event of music, like the inscrutable Play of Heidegger, is autogenic: it happens by itself and of itself. The event is the event of the soul which, like the Rose, is an unexplained blossoming, an *ebullio* out of its own core; it is self-moving. The kind of identity, therefore, we have in Heidegger and Eckhart has nothing to do with the empty unity of a thing with itself, the logician's $A = A$. Identity means "belonging together"; it is a verbal identity (not nominal), i.e., something to be accomplished. "Belonging together" is a process by which "Man and Being are appropriated [*übereignet*] to each other."[48] In Caputo's words, Being and man "do not sink into a motionless unity but each brings the other into its own. This unity . . . is not 'still' but rather vibrates with the movement of the mission of Being (*Seinsgeschick*). . . . It is not a union which takes place in an eternal now . . . [but] an historical coming to pass."[49]

We are witnessing in Heidegger a kind of unity which is as far removed as possible from the deceptive Apollonian unity *produced by ego consciousness*. What the ego creates is a simulacrum of unity, a monster that swallows up all multiplicity and difference. On the philosophical plane, such unities have assumed the form of various "isms"—monism, pantheism, panentheism, etc. The ego knows nothing about *Gelassenheit* except that it is a threat to its security, and in the ego's hell there is no dancing

119

and no fertility. The ego has no "wife," and its "virginity" is the sterile virginity of an eternal eunuch.

Heideggerian unity is that of the Heraclitean river—dynamic in its very stillness and at rest in its very changeability. There is constant movement but no progression toward fulfillment or actualization. The river is not fulfilled in the lake or in the ocean, and the ocean is not a utopia for the river. Hillman has said that in our culture we have fatally confused movement ("operative identity") with progressive growth toward wholeness, unity, perfection, and what not. "We call adaptation 'growth', and even suffering and loss part of 'growing'. We are urged, nay expected, to 'keep growing' in one way or another right into the coffin."[50]

Turning to archetypal psychology, I find that its mystical core, such as it is, rests on the insight that wholeness or unity is in the image.[51] I also submit that this insight, expressed in a widely differing language and deriving, as it does, from a different ethos, is nevertheless assimilable to Heidegger's musings on things and Gods. Hence, probably the best way to find out what Heidegger is 'all about' is to reduce his essential thought to the level of polytheism or, as Corbin prefers to call it, "mystical kathenotheism." To the Heideggerians who may resent the word "reduce," I suggest that the late Heidegger dwells in the neighborhood of mystical polytheism.

According to Hillman, unity is not a balanced mixture or a reconciliation of differences but "the realization that *differences are each images* which do not deny each other [or] oppose each other. . . . Each thing is a conjunction when consciousness is metaphorical [read: "re-leased"], and there are no halves or realms to be joined."[52] Metaphorical consciousness is malleable, bending, supple; like Chinese Tao or a Rabbinical story, it may mean this or that, but its meaning never congeals into allegory, parable, or symbol.[53] Any sort of union is paradoxical; it "hears various disparate voices at once . . ." and is "more like an ab-

surd pun than a bliss of opposites transcended. *Ananda* (bliss) in the joy of a joke."[54] On another occasion Hillman defines wholeness as meaning *"everything*—all the phenomena as phenomena, things as they present themselves." This is "psychological wholeness" pointing to "what one is as one is in multiple relations."[55]

Hillman's emphasis on multiplicity and diversity of imaginal presentations stems from the Jungian discovery of the polycentricity of the psyche. Jung envisioned psyche as a field of multiple and luminous particles which are like sparks or scintillae and which correspond to tiny conscious phenomena. In one of the clearest formulations of his concept of "multiple luminosities," Jung says that it "testifies to the personality- or ego-character of psychic complexes: just as the distinguishing mark of the ego-complex is consciousness so it is possible that other, 'unconscious' complexes may possess, as splinter psyches, a certain luminosity of their own."[56]

Jung's polycentric description of the psyche is, in effect, nothing more than an up-to-date confirmation of the gnostic idea of the circle whose center is everywhere: our center is multiple. We are not one but many, and yet at the same time we are—potentially—one (whole) at every instant of circulation. Oneness in this sense does not exclude multiplicity but demands it. I am truly what I am when I am *everything*, but—and this is a crucial qualification—at a time. *I am (potentially) everything at a time.*

The above phrase is an attempt to interpret in a mystical sense the following declarative statement by Hillman: "Polytheistic psychology would not suspend the commandment to have 'no other gods before me,' but would extend that commandment for each mode of consciousness."[57] As formulated by Miller, this means "worshipping one God at a time in a large pantheon" or being "gripped by one God at a time."[58] Within the context of the history of religions, such an attitude is called

kathenotheism (the word was coined by Max Müller). For example, in Hinduism, each God is exalted and praised as creator, source, and sustainer of the universe when the worshiper stands in the presence of that deity. "There are many gods, but their multiplicity does not diminish the significance or power of any of them. Each of the great gods may serve as a lens through which the whole of reality is clearly seen. . . . Each has its hour. . . . Each is seen, by those who are devotees, as Supreme in every sense."[59]

Hillman is not interested in reviving pagan polytheism; he is merely acknowledging an ancient belief that our psyche is dominated by numinous powers—Gods or archetypes—which manifest themselves always in our behavior. In Hillman's words, "polytheistic psychology takes . . . the Gods, mythically, in their own language, and not literally, idolatrously, as objects of belief."[60] As if to reassure the monotheistic theologian, he states:

> We are not out to worship Greek Gods—or those of any other polytheistic high culture. . . . We are not reviving a dead faith. For we are not concerned with faith . . . or with the life or death of God. Psychologically, the Gods are never dead; and archetypal psychology's concern is not with the revival of religion, but with the survival of soul.[61]

So, then, the sentence "I am (potentially) everything at a time," therapeutically and mystically understood, would mean attentiveness to and careful noticing (*notitia*) of the God who happens to dominate my field of consciousness at any given moment of time. As in meditational practice (or "meditative thinking"), it means doing one thing at a time. In such moments I am everything because, firstly, each God embodies the whole of reality (wholeness in the image) and, secondly, because careful noticing abolishes the distance between 'my' seeing and the object of seeing. I am seeing with the same eyes with which the

God sees. In this way I am released from multiplicity and dispersal, not by ignoring or transcending it, but precisely by fully and radically immersing myself in it. Time is redeemed through time. Or, as Tantric Buddhism has it, "by what men fall, by that they rise" (*Kulāvarnava-Tantra*). There is an echo of this in Goethe's lines: "If you want to approach the Infinite/Examine the finite on every side" (Willst Du ins Unendliche schreiten/ Gehe im Endlichen nach allen Seiten).

Heidegger's thought, like that of Hillman, is decidedly this-worldly. The expression "this-worldly," however, must not be understood in a crudely empirical sense. The world for both Hillman and Heidegger is a subtle reality, a celestial Earth which is unimaginable without the constant presence of Gods. All things and events in the world are established and maintained in Being by divine influx. In the language of archetypal psychology, Gods constitute the imaginal *esse* of things, and to that extent they are ultimate realities beyond which there is nothing, the "wild waste" of Eckhart or the *deitas abscondita* of apophatic theology. I shall return to this point in a moment. In the meanwhile, let me dwell briefly on the striking similarity that exists between Heidegger's and Hillman's this-worldliness and that of Homeric Greece.

W. Otto has convincingly shown that the peculiar character of the ancient Greek Gods consists in the fact that they do not disturb the natural order of things. A deity for the Greeks "is neither a justification nor a disruption or elimination of the natural course of the world; it is this natural course itself."[62] The Greek deity does not stress itself but lets the natural event be what it is. For example, Athene, by strengthening wind for Telemachus, makes the wind, in a way, more windy just as the Heideggerian artist makes the shoes more essentially shoe-like. This means, in Vycinas's words, that "things themselves, the way they naturally are, were somewhat divine for the Greeks. . . . A god did not have to distort the natural order in order to

reveal himself. On the contrary, the very natural, as such, revealed the divine as that which supports the natural in its being."[63] In a word, Gods are the truth (*aletheia*) of the world and "to be subordinated to the gods means to be open to the world or to be in the world."[64] In the last resort, it means to be released, that is, to be authentically human. Greeks who amazed the world with their genius never overestimated the dignity of man whom the chorus in Sophocles' *Antigone* calls "the uncanniest of all things uncanny." Without the Gods, man, as Pindar says, is only the "shadow of a dream."[65]

That Heidegger fully shares the Greek view of man may be gathered from the way in which he understands Heraclitus's saying *ēthos anthrōpō daimon*, whose usual translation is "A man's character is his daimon." According to Heidegger, "this translation is modern but not Greek thinking." *Ethos* means "abode," "place of dwelling," i.e., the open sphere in which man dwells. "The abode of man contains and maintains the advent of that to which man in essence belongs. This, according to Heraclitus's saying is [*daimon*], God. The fragment says: Man, insofar as he is man, dwells in the nearness of God."[66]

We are real or authentic insofar as we dwell in the nearness of Gods. There is no such thing as human identity in the sense of sameness. We are what the Gods imagine us to be and how we respond to the divine imagination from moment to moment. We are real only insofar as we are imaginal. In Heidegger's exclamatory remark, one must "behold man's nature without looking at man!"[67] To understand man we must first look at the Gods for, as Hillman says, "our . . . human individuality is really *not human at all*, but more the gift of an inhuman daimon who demands human service."[68]

But what is mystical about all this? The answer depends on the relationship one envisions between the mysticism of *via negativa*, on the one hand, and polytheism or kathenotheism on the other. We just saw that the Gods of the Heideg-

gerian–Hillmanian *mundus imaginalis* constitute the very ground upon which we stand; they are our "lunar mind." Even more crucially, however—at least for the present purposes—the imaginal world, according to Corbin, is intimately related not only to the empirical world of time and space but also to the *deitas abscondita* or *Theotes* (as Corbin calls it) of apophatic theology. Hillman as well has admitted that the process of psychologizing or "seeing through" the literalisms of ordinary experience can only be justified by an appeal to an "ultimate hidden value" which "can . . . be called the hidden God (*deus absconditus*)."[69] There is also the enigmatic observation, made by Heidegger, about the God of the philosophers before whom "man . . . can neither fall on his knees timidly, nor . . . play music or dance." Accordingly, says Heidegger, "the god-less thinking which must abandon the god of philosophy . . . is thus perhaps closer to the divine God."[70]

Is "the divine God" identical with Heidegger's "Being"? We cannot decide this question within the limits of the present inquiry. What seems to be certain is that the entire thrust of Heidegger's thought lies in his rejection of the onto-theological framework of Western metaphysics in favor of a quasi-mystical notion of Being which bears striking resemblance to Eckhart's "divine abyss," "Nothing," etc., and whose depth eludes every conceptual net thrown over it. Being cannot be manipulated and is completely "useless."

Now Corbin, as if following in the footsteps of Heidegger, states that the "metaphysical catastrophe" of the West consists precisely in confusing Being ("the divine God") with a Supreme Being (*ens realissimum*). Western monotheism has elevated "an idol just at the point where it denounces such in a polytheism it poorly understands."[71] It is also this confusion which has prepared "the death of God": what has died is an idol—the Supreme Being of theology and philosophy. According to Corbin, the God of monotheism is a *theophany*, i.e., one of the

many, indeed, innumerable manifestations of *Theotēs* (Heidegger's Being or the "divine God"). In effect, "the unity of *Theotēs* entails, conditions, and guarantees the plurality of the *theoi* (gods), just as the [Heideggerian] unity of Being entails and conditions the plurality of beings."[72] For it is precisely because "the divine God" is hidden and concealed that it demands a multiplicity of forms (images) in which to reveal itself. In Corbin's words, "it is in the very nature of the *Theotēs* (*deitas abscondita*) to be revealed and made manifest by the plurality of its theophanies, in an unlimited number of theophanic forms."[73] What this implies is that the rebirth of Gods (polytheism) advocated by archetypal psychology cannot take place without a simultaneous re-appropriation of the negative theology of the West or, to put it in Heideggerian terms, without a persistent meditation on "the divine God" of the mystics. Mystical polytheism—as distinguished from religious or idolatrous polytheism—is inseparable from apophatism.

Corbin believes that polytheism, properly understood, is kathenotheism or "mystical kathenotheism."[74] Kathenotheism holds that "the Divine Being is not fragmented, but wholly present in *each* instance, individualized in *each* theophany of His Names. . . ."[75] The basic premise here is that theophanies are always proportionate to the soul's capacity to receive them. A theophanic vision is essentially "an *event of the soul*, taking place *in* the soul and *for* the soul. As such its reality is . . . *individuated* for and with each soul; what the soul really sees, it is in each case alone in seeing. The field of its vision, its horizon is in every case defined by the capacity, the dimension of its own being."[76] "This," says Corbin, "is the gnostic formulation *par excellence*." Moreover, "the God of the gnostics can never die because he is himself [the place of] the renaissance of Gods and Goddesses."[77]

Finally, every theophany is also an angelophany, for the "form of God" encountered by the mystic is that of his angel. The angel is not a simple messenger transmitting orders, not the

usual "guardian angel," but the form (image) under which the (polytheistic) mystic knows God and through which God knows the mystic. "The Angel is the Face that . . . God takes for us, and each of us finds his God only when he recognizes that Face."[78]

The realm of angels must not be imagined as being outside of time and space. Angels, like Gods, are the very ground on which we walk, even though, as Heraclitus would say, it "loves to hide" (fr. 17, Wheelwright). In Hillman's words, our "angelic originality" is "forever possible" so long as "all terrestrial and material events" are "led back by the act of *ta'wil* (return) to the angelic ground in the white earth."[79] For the angelic mind, the mystical is not in undifferentiated unity, not in Wittgenstein's "*That* [the world] is" (*Tractatus*, 6. 44), not even in Leibniz's *angst*-laden "Pourquoi il y a quelque chose plutôt que rien?"— but in the minute particulars of things, in their phenomenal faces. Mysticism is essentially a polytheistic style of consciousness that sees soul in each thing or, as Heidegger would prefer to say, that lets things thing and so re-leases them into their own being.

At the beginning of this essay, a reference was made to Heidegger's phrase about "needy times"—a destitute time because it languishes between a "no longer" of the Gods and a "not yet" of the God. In view of what we have said in the immediately preceding pages, Heidegger would seem to be off the mark: it is not the Gods who have fled but the monotheistic God of Western onto-theology. Miller therefore would like to revise his phrase to read: "It is the time of no-more of the God who has fled and the not-yet of the Gods who are coming."[80]

Surely, Heidegger's dictum is polysemous enough to allow for divergent interpretations. For one thing, Vycinas speculates that "the approaching god of the future . . . should not be considered as the Christian God returning after the exile of the nihilistic 'God is dead' period, but the god as the messenger of

Being." Moreover, this god of the future is a "worldly god," "a fundamentally worldly reality."[81] Notice also that the word "god" in the expression "the approaching god" is used in the singular and written with a small "g." Elsewhere, Heidegger has stated that "the divinities are the beckoning messengers of the godhead."[82]

In my opinion, these statements, taken together, suggest that the flight of the Gods from our world is intimately connected with what Corbin calls the "metaphysical catastrophe" of the West, i.e., with the fact that one of the Gods has been identified with Being or *deitas abscondita* and subsequently elevated into the "only true God." In other words, the West has forgotten that Being manifests itself as appearing, that is to say, in *many* Gods and Goddesses. Oblivion of Being is the oblivion of imagination.

But who is the "approaching god"? It could well be that what Heidegger has in mind is not so much a worldwide revival of polytheistic consciousness as it is the possibility that the monotheistic God of the West may undergo a transformation of such proportions that He will re-appear as the "messenger of Being." Heidegger's may be a kathenotheistic expectation, a waiting for the messenger of "the divine God" who will be worshiped in a form that is congruous to the capacity of the worshiper. It would be an "event of the soul, taking place *in* the soul and *for* the soul." There are certainly signs indicating that something of the sort is in the making. Most theologians today have ceased to insist on the exclusive character of Christianity and are beginning to see it—reluctantly to be sure—as only one of the "great religions of the world." The history and phenomenology of religions have made an inestimable contribution to this changing outlook. What is still lacking, however (with the exception of the extraordinary efforts of a Corbin), is a phenomenology of the *mundus imaginalis*—of the "religious" events taking place, not in the exterior world of historical facts, but in the subtle

world of the soul. For this, the Western monotheistic *theologoi* will have to go beyond pious elucubrations about the necessity of a dialogue among Christians and confront the dizzying possibility that the *religio Christiana*, instead of being the "fulfill-ment" of paganism (Augustine), needs pagan polytheism as the condition of its own survival. To save the phenomenon of Christianity, it is first necessary to save the phenomena themselves: appearances, things, images, Gods, angels.

Let me, then, rephrase Heidegger by saying that the "needy time" is "the time of the 'no-more' of the one and only God who has fled and the 'not-yet' of the gnostic God who is coming." There is really nothing grandiose about such coming and such expectation. We begin with shoelaces or, in my version of mystical polytheism, we begin by paying attention to shoelaces and forget—"while the music lasts" (T. S. Eliot)—about the Shoemaker.

Notes

The *Collected Works of C. G. Jung*, translated by R. F. C. Hull, have been published in the United States by the Bollingen Foundation (Bollingen Series XX). Since 1967, the American publisher has been the Princeton University Press, Princeton, New Jersey. The volumes are referred to herein as *CW*, and passages are cited by volume and paragraph (§) numbers.

Introduction: Gnosis

1. The French Islamic scholar and mystic Henry Corbin (1903-78) has won lasting fame by revealing and revalorizing a little-known Islamic philosophical tradition, Ismaelism and the esoteric trends in ancient and medieval Iran. The areas of his investigations also include gnosis, hermeticism, Jewish mysticism, Jacob Boehme, Emanuel Swedenborg, and Martin Heidegger. The pivotal figure in Corbin's writings and meditations is Suhrawardī (1155-91) who revived in Iran the wisdom of the ancient Persians in their doctrine of Light and Darkness. The most original feature of Suhrawardī's thought is his interpretation of the Platonic ideas in terms of the Zoroastrian angels (Mazdean "angelology"). Following Suhrawardī, Corbin was led to introduce the conception of a third world, the world of archetypal figures (angels) or *mundus imaginalis* (*alammithāl*) lying between the intelligibles and the realm of sensible things. The kind of knowledge appropriate to this intermediary world is visionary perception or imagination (inner revelation). Corbin uses the adjective "imaginal" in order to distinguish visionary imagination from "the imaginary" (fictitious, unreal). (See his article "*Mundus Imaginalis* or The Imaginary and the Imaginal" in *Spring 1972* : 15.) Besides his work on Suhrawardī (see vol. II of his magnum opus *En Islam Iranien*, 4 vols. [Paris: Editions Gallimard, 1977], Corbin has written on Avicenna, Ibn 'Arabi, and other illuminationist philosophers. His phenomenological method is a further development of Heidegger's phenomenology. The true phenomenon for Corbin is spiritual experience, i.e., an event of the soul which by definition is not open to common sensory observation and which can be shared only by those who participate in similar spiritual experiences. Phenomenology, as a proper interpretation and understanding of the phenomena, is inseparable from the mode of being of the interpreter.

Notes

Hillman has acknowledged Corbin as being, besides Jung, "the second immediate father of archetypal psychology." The common denominator uniting Jung, Hillman, and Corbin is the concern with the "development of a sense of soul" and "the cultivation of imagination." (See James Hillman, *Archetypal Psychology: A Brief Account* [Dallas: Spring Publications, 1983], p. 4; cf. p. 5 on "tripartite anthropology.")

2. Historically, gnosis constitutes the esoteric element in the official or exoteric religious traditions of the world. As such it must be distinguished from gnosticism which flourished before, during, and after the rise of Christianity. The predominant view of gnosticism is that of a radically dualistic religious movement positing the existence of two equal and contrary forces in the universe: a good God and the evil Demiurge. The good God did not produce the world, and he doesn't rule over it: he is transmundane, acosmic, unknowable. The Demiurge is an inferior God responsible for the creation of the world and all the calamities issuing from this act. Gnosticism sees man as a misplaced spark (*pneuma*) of the divine light, engulfed in darkness through no fault of his own. He must struggle to free himself from the mortal encasement and soar back to the empyrean realm from which he came.

For the vast literature treating gnosticism in a dualistic sense, see Henry-Charles Puech, "Gnosis and Time," in *Man and Time: Papers from the Eranos Yearbooks 3* (Princeton, N. J.: Princeton University Press, 1957), pp. 38–84; Hans Jonas, *The Gnostic Religion* (Boston: Beacon Press, 1958). Jonas's estimation of Heidegger (Chap. 13: "Epilogue: Gnosticism, Existentialism, and Nihilism") as a gnostic in the "heretical" religious sense is misleading in that it fails to take into consideration the poeticizing thought of the later Heidegger which, in any event, should not be seen as a repudiation of the insights achieved during the *Being and Time* period. It is also important to note that the dualistic view of Gnosticism, including that of Jonas, has been corrected in recent scholarship. See William Schoedel, "Gnostic Monism and the Gospel of Truth," in *The Rediscovery of Gnosticism*, ed. Bentley Layton, vol. 1 (Leiden: E. J. Brill, 1980), pp. 379–90; Joel Fineman, "Gnosis and the Piety of Metaphor," *Rediscovery*, pp. 289–313.

3. See David L. Miller, *The New Polytheism: Rebirth of the Gods and Goddesses*, Prefatory Letter by Henry Corbin, Appendix by James Hillman (Dallas: Spring Publications, Inc., 1981), p. 132; Hillman, *Archetypal Psychology*, p. 54.

4. Martin Heidegger, *Existence and Being*, Introduction and Analysis by Werner Brock (South Bend, Ind.: Gateway Editions, Ltd., 1949), p. 289.

5. W. B. Yeats, "The Second Coming," *Collected Poems of W. B. Yeats* (Macmillan Pub. Co., Inc., 1924).

6. Letter to George and Thomas Keats, December, 1917, in John Keats, *The Letters of John Keats*, ed. Maurice B. Forman (London: Oxford University Press, 1952), p. 71.

Notes

7. See *Symp.* 195 B, *Lys.* 214 B, *Gorg.* 510 B; Plotinus, *Enneads* 1. 6. 9. In Meister Eckhart's platonizing thought we find the following: "He who wants to understand my teachings of detachment has to be himself perfectly detached" (*Die deutsche Werke* [Stuttgart, 1936 ff.], II : 71). The Sufi Master Najm Kobra states: "you see and discern nothing whatsoever except by means of something that is its like (or which is a part of it)" (see Henry Corbin, *The Man of Light in Iranian Sufism* [Boulder, Co.: Shambhala, 1978], p. 71). Speaking for the Far Eastern tradition T. Isutzu says: "the world discloses to your eyes in exact accordance with the actual state of your consciousness" ("The Structure of Selfhood in Zen Buddhism," *Eranos Jahrbuch* 38—1969 [Zürich: Rhein, 1972], p. 102). Note also the following observation: "The Zen Buddhist is not interested in the shift of viewpoints or the kinds of interest from which an object may be looked at, while the 'subject' remains always on one and the same level of daily experience. Rather, he is thinking of two totally different dimensions of consciousness; that is, he is interested in a sudden, abrupt shift on the part of the perceiving subject from the daily consciousness to that of supra-consciousness" (ibid., p. 1030). There is also a similar idea in Heidegger: "Sight does not determine itself from the eye but from the light of Being" (*Holzwege* [Frankfurt a/M: Klostermann, 1950], p. 322).

8. Henry Corbin, "The Eyes of the Flesh and Eyes of Fire; Science and Gnosis," *Material for Thought* 8 (1980) : 6.

9. C. G. Jung, CW 9ii, §269; cf. CW 18, §707-09.

10. Jacob Needleman, *Lost Christianity* (Garden City, N. J.: Doubleday & Co., Inc., 1980), p. 37.

11. Corbin, "The Eyes of the Flesh," p. 7. The idea of the correlation of knowledge and being is also part of the cluster of non-dualistic currents associated with "perennial philosophy" or *sophia perennis* (sometimes referred to as "Tradition") whose main contemporary representatives are René Guenon (1886-1950), Ananda K. Coomaraswamy (1877-1947), Frihjof Shoun (1907-), Titus Burckhard, Marco Pallis, Martin Lings, Kathleen Raine, Jacob Needleman, etc. The term *philosophia perennis* was probably used for the first time by Augustine Steuco (1497-1548), the Renaissance philosopher and theologian whose work *De perenni philosophia* was influenced by Ficino and Vico. Ficino often spoke of *philosophia priscorum* or *prima theologia* (ancient or venerable philosophy) by which he mainly meant the Platonic tradition. Plato, for Ficino, as for many Christian Platonists, was a "Greek-speaking Moses." Ficino's compatriot Pico della Mirandolla adds the Quran, Islamic Philosophers, and Kabbala to the sources of *philosophia priscorum*. Perennial philosophers hold that "wisdom" antedates the whole historical period and is attainable through either its embodiment in various religious traditions or by intellectual intuition. For detailed information about the historical derivation of *philosophia perennis*, see C. Schmidt, "Perennial Philosophy: Steuco to

Notes

Leibniz," *Journal of the History of Ideas* 27 (1966) : 506. A recent and thorough discussion of philosophical and religious issues from the viewpoint of perennial philosophy is found in Seyyed Hossein Nasr, *Knowledge and the Sacred*, The Gifford Lectures, 1981 (New York: Crossroad, 1981).

The sapiential tradition has exercised a formative influence on many of the major figures of early Christianity: St. Gregory of Nyssa and Gregory of Nazianzus, the early desert fathers and the community which produced the Nag Hammadi texts; Clement of Alexandria (140–c. 220) saw Christianity as a way of wisdom and (like Blake) identified Christ with the Universal Intellect (the Aristotelian *Nous*). In their view, the true sage is one who has first achieved moral perfection and subsequently became a "true gnostic." Later in time we have the emergence of Lutheran spirituality in the works of Sebastian Frank, Paracelsus, V. Weigel, Jacob Boehme, F. C. Oetinger, and the Cambridge Platonists in eighteenth-century England: Benjamin Whichcote, Ralf Cutworth, Henry More, and John Smith—thinkers who are concerned with the "intermediate world." In eighteenth-century France the prominent Platonists were Claude Saint-Martin, Joseph de Maistre, Fabre d'Oliver, Hone Wronski, and, in Italy, Antonio Rosmini.

12. Jacob Needleman, *Consciousness and Tradition* (New York: Crossroad, 1982), p. 157.

13. William Blake, *Blake: Complete Writings*, ed. Geoffrey Keynes (London: Oxford University Press, 1966), p. 793.

14. Henry Corbin, *Creative Imagination in the Sufism of Ibn 'Arabi* (Princeton, N. J.: Princeton University Press, 1969), p. 222.

15. Ibid., p. 264.

16. Henry Corbin, "Necessité de l'angélologie," *L'Ange et l'homme* (Paris: Albin Michel, 1979), p. 66. The cited passage is a translation by David L. Miller in his "Theologia Imaginalis," *The Archaeology of the Imagination*, ed. Charles E. Winquist, Journal of the American Academy of Religion Thematic Studies 48/2 : 9.

17. Ibid.

18. Miller, "Theologia Imaginalis," p. 10.

19. James M. Robinson, ed., *The Nag Hammadi Library*, 2 vols. (New York: Harper & Row, 1977), 2 : 189.

20. James Hillman, "Abandoning the Child," *Eranos Jahrbuch* 40—1971 (Leiden: E. J. Brill, 1973), p. 357.

21. Hillman, *Archetypal Psychology*, p. 26.

22. James Hillman, *Re-Visioning Psychology* (New York: Harper & Row, 1975), p. x.

23. Heidegger's handling of all the major figures of Western philosophy, including the pre-Socratics, is based on his notion of "retrieve" (*Wiederholung*). Retrieve is essentially a dialogal stance which aims at disclosing what a thinker

Notes

"did not say, could not say, but somehow made manifest" (William J. Richardson, S. J., *Heidegger: Through Phenomenology to Thought* [The Hague: Martinus Nijhoff, 1974], p. 159).

24. Hillman, *Re-Visioning Psychology*, pp. 140–41.

25. Ibid., p. 152.

26. Ibid. Elsewhere Hillman says that the search for origins "is for what continues to create in the psyche, for the specific nature of the creative principle" (James Hillman, *The Myth of Analysis: Three Essays in Archetypal Psychology* [Evanston: Northwestern University Press, 1972], p. 18). The implication of this statement is that "the beginnings of every deep human question . . . lie in the *mundus imaginalis*" (James Hillman, *Loose Ends: Primary Papers in Archetypal Psychology* [Spring Publications, 1975], p. 33).

27. Martin Heidegger, *What is Called Thinking?*, trans. Fred D. Wieck and J. Glenn Gray (New York: Harper & Row, 1968), p. 169.

28. Martin Heidegger, "Letter on Humanism," *Philosophy in the Twentieth Century, an Anthology*, ed. William Barrett and Henry D. Aiken (New York: Random House, 1962), 2 : 292.

29. P. Kreeft, "Zen in Heidegger's *Gelassenheit*," *International Philosophical Quarterly* (December, 1971) : 539.

30. Friedrich Nietzsche, *The Philosophy of Nietzsche* (New York: Modern Library, 1927), p. 11.

31. Hillman, *Re-Visioning Psychology*, p. 246, n. 6.

32. Martin Heidegger, *Nietzsche* I (Pfullingen: Neske, 1961), p. 583. Author's trans.

33. Thomas J. Sheehan, "Getting to the Topic: The New Edition of *Wegmerken*," in *Radical Phenomenology: Essays in Honor of Martin Heidegger*, ed. John Sallis (Atlantic Highland, N. J.: Humanities Press, 1978), p. 302.

34. Heidegger, "Letter on Humanism," *Philosophy in the Twentieth Century*, p. 298.

I: Soul and World

1. The question of early Heidegger versus late Heidegger—the *locus classicus* of Heideggerian scholarship—is exhaustively treated in William J. Richardson, *Heidegger: Through Phenomenology to Thought* (The Hague: Martinus Nijhoff, 1974); see especially the preface by Heidegger, pp. vii–xxiii. The present study, assuming an essential continuity between Heidegger I and II, concentrates on the artistic and geocentric part of his thought. For my discussion of the geocentric aspect, I am indebted to Vincent Vycinas's *Earth and Gods: An Introduction to the Philosophy of Martin Heidegger* (The Hague: Martinus Nijhoff, 1969).

Notes

2. Martin Heidegger, *Being and Time*, trans. John Macquarrie and Edward Robinson (New York: Harper & Row, 1962), p. 67.

3. Martin Heidegger, "Letter on Humanism," *Martin Heidegger: Basic Writings*, ed. David Farrell Krell (New York: Harper & Row, 1977), p. 205.

4. Vycinas, *Earth and Gods*, pp. 69–70.

5. Martin Heidegger, "Letter on Humanism," *Philosophy in the Twentieth Century, an Anthology*, ed. William Barrett and Henry D. Aiken (New York: Random House, 1962), 2 : 288.

6. Martin Heidegger, *What is Called Thinking?*, trans. Fred D. Wieck and J. Glenn Gray (New York: Harper & Row, 1968), p. 203.

7. Ibid., p. 207.

8. William Barrett, *Irrational Man* (Garden City: N. J.: Doubleday Anchor Books, 1962), p. 213; cf. Heidegger, *Being and Time*, pp. 25, 241.

9. Heidegger, *Being and Time*, pp. 89–90.

10. Ibid., p. 249.

11. James Hillman, *Inter Views* (New York: Harper & Row, 1983), p. 140.

12. Martin Heidegger, *Einführung in die Metaphysik* (Tübingen: Niemeyer Verlag, 1953), p. 77. Cited and trans. Vycinas, *Earth and Gods*, p. 102.

13. For a comparison between Being and light, see William Barrett, *The Illusion of Technique* (New York: Anchor Press/Doubleday, 1978), p. 188.

14. James Hillman, *Re-Visioning Psychology* (New York: Harper & Row, 1975), p. x.

15. Martin Heidegger, *Early Greek Thinking*, trans. David Farrell Krell and Frank A. Capuzzi (New York: Harper & Row, 1975), p. 103.

16. Martin Heidegger, *An Introduction to Metaphysics*, trans. Ralph Manheim (New Haven: Yale University Press, 1959), p. 106.

17. Robert Romanyshyn, "Psychological Language and the Voice of Things," *Dragonflies: Studies in Imaginal Psychology* (Spring 1979) : 74.

18. Michael E. Zimmerman, *Eclipse of the Self: The Development of Heidegger's Concept of Authenticity* (Athens: Ohio University Press, 1981), p. 153.

19. The text is given in C. Baeumker, "Das pseudo-hermetische Buch der vier und zwanzig Meister (*Liber XXIV philosophorum*), ein Beitrag zur Geschichte des Neupythagoräismus und Neuplatonismus im Mittelalter," in M. Baumgartner et al., *Abhandlungen aus dem Gebiete der Philosophie and ihrer Geschichte* (Freiburg i/B, 1913), pp. 17–40. Our hermetic science has been taken over and elaborated by a number of philosophers: Alain de Lille, Vincent de Beauvais (who assigns it to Empedocles), St. Augustine, the Cambridge Platonists, Nicholas Cusanus, Pascal, Nietzsche, Jung, etc.

20. Heidegger has been criticized for relying upon dubious etymology of Greek words. The case of *aletheia* has been cogently discussed by Paul Friedländer, *Plato 1*, trans. Hans Meyerhoff, Bollingen Series (Princeton, N. J.: Princeton University Press, 1958), pp. 221–29. Heidegger himself, however, has

Notes

pointed out that the Greek understanding of *aletheia* is not an etymological issue but a question of "how the presencing of what is present comes to language only in shining, self-manifesting, lying before, arising . . . and assuming an outward appearance" (*Vorträge und Aufsätze*, cited by John Caputo, *Heidegger and Aquinas* [New York: Fordham University Press, 1982], p. 192). According to Caputo, "even if the etymology of *aletheia* is otherwise than Heidegger describes it, it is nonetheless true in terms of light and darkness, shining and appearing—in a word, unconcealment" (ibid., pp. 192-93). The problem of etymology in the light of Owen Barfield's discoveries is discussed by G. B. Tennyson, "Etymology and Meaning," in *Evolution of Consciousness: Studies in Polarity* (Middletown, Conn.: Wesleyan University Press, 1976), pp. 168-83.

21. Caputo, *Heidegger and Aquinas*, p. 206. Cf. Heidegger, *Early Greek Thinking*, pp. 108-15.

22. Fritjof Capra, *The Tao of Physics* (New York: Bantam Books, 1975), p. 198.

23. Barrett, *The Illusion of Technique*, pp. 145-46.

24. Hillman, *Re-Visioning Psychology*, p. 121.

25. Friedländer, *Plato* 1, pp. 14-18.

26. Hillman, *Re-Visioning Psychology*, p. 121.

27. James Hillman, "The Fiction of Case History: A Round," in *Religion as Story*, ed. James B. Wiggins (New York: Harper & Row, 1975), p. 158.

28. James Hillman, "Anima Mundi: The Return of the Soul to the World," *Spring 1982* : 77.

29. Friedländer, *Plato* 1, p. 21.

30. Heidegger, "Letter on Humanism," *Philosophy in the Twentieth Century*, p. 293.

31. Jung, *CW* 8, §666. For a discussion of myth, see Henry Frankfort, et al., *The Intellectual Adventure of Ancient Man* (Baltimore: Penguin Books, 1967), pp. 14, 25-36; Ernst Cassirer, *The Philosophy of Symbolic Forms*, vol. 2, *Mythical Thought* (New Haven: Yale University Press, 1955); Roberts Avens, *Imaginal Body: Para-Jungian Reflections on Soul, Imagination and Death* (University Press of America, 1982), pp. 68-80.

32. Hillman, *Re-Visioning Psychology*, p. 17; cf. pp. 12-15.

33. See Jung, *CW* 6, §78 ff.

34. Hillman, *Re-Visioning Psychology*, p. 173; cf. pp. 174-77.

35. Heidegger, *Being and Time*, p. 170.

36. Martin Heidegger, *Discourse on Thinking*, a translation of *Gelassenheit* by John M. Anderson and E. Hans Freund (New York: Harper & Row, 1966), p. 58; cf. p. 78.

37. Hillman, *Re-Visioning Psychology*, p. 175.

38. Ibid., p. 180.

Notes

39. Cited by James Hillman, "Back to Beyond: On Cosmology," unpublished paper presented at the Conference "Whitehead, Jung and Hillman," Center for Process Studies, Claremont, Calif., February 1983, typescript pp. 9b, 10b.

40. Patricia Berry, "An Approach to the Dream," *Spring 1974* : 63-64.

41. Ibid., p. 68.

42. Edward S. Casey, *Imagining: A Phenomenological Study* (Bloomington: Indiana University Press, 1976), p. 95.

43. Hillman, "Back to Beyond," p. 11.

44. H. de Balzac, "Le Chef d'Oeuvre Inconnue," *Etudes Philosophiques* XVII (Paris, 1837).

45. See Avens, *Imaginal Body*, pp. 7-13.

46. See James Hillman, *Archetypal Psychology: A Brief Account* (Dallas: Spring Publications, 1983), pp. 7-8.

47. William Blake, *Blake: Complete Writings*, ed. Geoffrey Keynes (London: Oxford University Press, 1966), p. 522.

48. Hillman, "Anima Mundi," p. 88.

II: From Phenomenology to Angelology

1. The only exception in this regard is found in Heidegger's discussion of Kant in *Kant and the Problem of Metaphysics*, trans. Janes S. Churchill (Bloomington: Indiana University Press, 1962). Kant, according to Heidegger, was the first to single out imagination (*Einbildunskraft*) as the power (*Kraft*) within man to build (*bilden*) into synthetic unity (*ein*) both pure intuition and pure thought. The transcendental imagination was for Kant not merely one more faculty alongside sense and thought but the common source which permits both sensation and thought to spring forth. He called it "a grounding-power of . . . soul which lies as the ground for all a priori knowledge" (Immanuel Kant, *Critique of Pure Reason*, ed. Norman Kemp Smith [New York: Macmillan, 1933], A 124). In Heidegger's view, this means that imagination is not reducible to sense or to thought; rather, it is the dynamic, spontaneous process which "institutes itself." As to the question "What is instituted?" Heidegger's answer is unequivocal: transcendental imagination institutes transcendence, which in turn makes possible "the essence of human finitude." Transcendence is the "essence of the finite self" (*Kant and the Problem of Metaphysics*, p. 162). From this it seems clear that man cannot be described merely in terms of subjectivity. Dasein as transcendental imagination is not a subject but a trans- or pre-subjective self preceding the dichotomy of subject and object and rendering it possible. Imagination is an indeterminate unknown that lies between the

138

Notes

subject and the object. Heidegger, however, takes a further step by identifying the power of imaginative synthesis with time (primordial time). Time and imagination are the same; they constitute the ultimate horizon in which anything can appear as present, cognizable, and meaningful.

Heidegger thinks that Kant, in the first edition of the *Critique*, had uncovered the truth that knowledge is only possible because it is finite. He pointed to the source of this finitude, but finally, i.e., in the second edition of the *Critique*, he turned away from it. Kant was led to the edge of that blind but indispensable function of the soul, the common root of intuition and thought, and recoiled before it. He retreated from the primacy of imagination because it led to a ground which is more basic than sense and thought—to an "abyss." This discovery filled Kant with alarm, because between the first and the second editions of the *Critique* he had come more and more under the influence of pure reason as such. In the second edition, imagination, the indispensable "faculty of the soul," emerges as a mere function of understanding (reason). By turning away from the "psychological" interpretation of the first edition, Kant opts for the supremacy of reason (see *Kant and the Problem of Metaphysics*, pp. 172-74).

2. See Martin Heidegger, *Unterwegs zur Sprache* (Pfullingen: Neske, 1965), p. 38; *Holzwege* (Frankfurt a/M: Klostermann, 1950), pp. 60, 63.

3. See James Hillman, *The Myth of Analysis: Three Essays in Archetypal Psychology* (Evanston: Northwestern University Press, 1972), pp. 176ff.; *Re-Visioning Psychology* (New York: Harper & Row, 1975), p. xi.

4. James Hillman, "The Dream and the Underworld," *Eranos Jahrbuch* 42—1973 (Leiden: E. J. Brill, 1977), p. 257, note.

5. Martin Heidegger, *Being and Time*, trans. John Macquarrie and Edward Robinson (New York: Harper & Row, 1962), p. 58; cf. p. 50.

6. Martin Heidegger, *What is Called Thinking?*, trans. Fred D. Wieck and J. Glenn Gray (New York: Harper & Row, 1968), p. 8; cf. p. 50.

7. J. L. Mehta, *Martin Heidegger: The Way and the Vision* (Honolulu: The University of Hawaii Press, 1976), p. 101.

8. Vincent Vycinas, *Earth and Gods: An Introduction to the Philosophy of Martin Heidegger* (The Hague: Martinus Nijhoff, 1969), p. 29.

9. Richard E. Palmer, *Hermeneutics* (Evanston: Northwestern University Press, 1969), p. 128.

10. Martin Heidegger, *The Piety of Thinking*, trans. James G. Hart and John C. Maraldo (Bloomington: Indiana University Press, 1976), p. 42.

11. James Hillman, "The Thought of the Heart," *Eranos Jahrbuch* 48—1979 (Frankfurt a/M: Insel Verlag, 1981), p. 164.

12. Henry Corbin, *Creative Imagination in the Sufism of Ibn 'Arabi* (Princeton, N. J.: Princeton University Press, 1969), p. 3.

13. I am paraphrasing Miller's passage: "Angels are messengers. But since

Notes

they have no biographies, they bring no message. They are the message." See "Images, Angels, Bacon," *Corona* II : 8.

14. James Hillman, "Silver and the White Earth (Part One)," *Spring 1980* : 46.

15. See Palmer, *Hermeneutics*, p. 87; cf. pp. 24, 118-19.

16. Martin Heidegger, *On the Way to Language*, trans. Peter D. Hertz (New York: Harper & Row, 1971), p. 29.

17. Hillman, "The Dream and the Underworld," p. 257, n. 25.

18. William V. Spanos, "Heidegger, Kierkegaard, and the Hermeneutic Circle: Towards a Post-Modern Theory of Interpretation as Disclosure," *Boundary* 24 (Winter 1975) : 401.

19. David Miller, "Images of Happy Ending," *Eranos Jahrbuch* 44—1975 (Leiden: E. J. Brill, 1977), p. 87.

20. R. M. Rilke, *Duino Elegies and Sonnets to Orpheus*, trans. A. Poulin, Jr. (Boston: Houghton Mifflin Co., 1977), pp. 4-5.

21. David Miller, "Theologia Imaginalis," in *The Archaeology of the Imagination*, ed. Charles E. Winquist, Journal of the American Academy of Religion Thematic Studies 48/2 : 9.

22. James Hillman, "Image-Sense," *Spring 1979* : 142.

23. Hillman, *The Myth of Analysis*, p. 172.

24. Jung, CW 8, §402.

25. Jung, CW 9i, §155.

26. James Hillman, "On the Necessity of Abnormal Psychology," *Eranos Jahrbuch* 43—1974 (Leiden: E. J. Brill, 1977), pp. 95-96, n. 6.

27. Hillman, *Re-Visioning Psychology*, p. 125; cf. p. 141; *The Myth of Analysis*, pp. 173-74; "An Inquiry into Image," *Spring 1977* : 64, 75, 80.

28. James Hillman, "Egalitarian Typologies *versus* the Perception of the Unique," *Eranos Jahrbuch* 45—1976 (Leiden: E. J. Brill, 1980), p. 257.

29. Ibid.

30. Jung, CW 8, §748; CW 13, §378.

31. Hillman, *Re-Visioning Psychology*, p. 132.

32. David Miller, *The New Polytheism: Rebirth of the Gods and Goddesses* (New York: Harper & Row, 1974), p. 56.

33. Hillman, *Re-Visioning Psychology*, p. 181; cf. pp. 134, 173.

34. Ibid., p. 138.

35. See ibid.; cf. p. 139.

36. Ibid., p. 23.

37. Ibid., p. 140.

38. Paul Ricoeur, "The Task of Hermeneutics," *Heidegger and Modern Philosophy*, ed. Michael Murray (New Haven: Yale University Press, 1978), p. 151.

39. Hans-Georg Gadamer, *Philosophical Hermeneutics*, trans. David E. Linge (Berkeley: University of California Press, 1976), p. 120.

Notes

40. Hillman, *Re-Visioning Psychology*, p. 131.

41. Hillman, *The Myth of Analysis*, p. 179.

42. Hillman, *Re-Visioning Psychology*, p. 127.

III: Thought of the Heart

1. See Martin Heidegger, "Letter on Humanism," *Martin Heidegger: Basic Writings*, ed. David Farrell Krell (New York: Harper & Row, 1977), pp. 194-95.

2. See Martin Heidegger, *Discourse on Thinking* (New York: Harper & Row, 1966), pp. 45-46.

3. Martin Heidegger, *An Introduction to Metaphysics*, trans. Ralph Manheim (New Haven: Yale University Press, 1959), p. 122.

4. Heidegger, *Discourse on Thinking*, p. 58.

5. Ibid., p. 68; cf. p. 25.

6. J. Glenn Gray, "Introduction," in Martin Heidegger, *What is Called Thinking?*, trans. Fred D. Wieck and J. Glenn Gray (New York: Harper & Row, 1968), pp. xiv-xv.

7. Martin Heidegger, *Vorträge und Aufsätze. Vierte Auflage.* (Pfullingen: Neske, 1978), p. 187 (author's trans.). Cf. idem, *Early Greek Thinking*, trans. David Farrell Krell and Frank A. Capuzzi (New York: Harper & Row, 1975), pp. 79-101.

8. Heidegger, *What is Called Thinking?*, p. 241.

9. Ibid., p. 139.

10. Ibid., p. 140.

11. Ibid., p. 144.

12. Ibid., p. 149.

13. Ibid., p. 207.

14. Ibid.

15. Jacob Needleman, *Lost Christianity* (Garden City, N. J.: Doubleday & Co., Inc., 1980), p. 152.

16. Ibid., p. 153.

17. Ibid., p. 167.

18. James Hillman, "The Thought of the Heart," *Eranos Jahrbuch* 48—1979 (Frankfurt a/M: Insel Verlag, 1981), p. 136.

19. Ibid., p. 150.

20. Ibid., p. 161.

21. James Hillman, "Anima Mundi: The Return of the Soul to the World," *Spring 1982* : 84; cf. "The Thought of the Heart," p. 160.

22. Hillman, "Anima Mundi," p. 84; cf. "The Thought of the Heart," pp. 157, 159; "Image-Sense," *Spring 1979* : 143.

23. Hillman, "Image-Sense," p. 142.

Notes

24. Hillman, "Anima Mundi," p. 85.

25. Henry Corbin, *Spiritual Body and Celestial Earth*, trans. Nancy Pearson (Princeton, N. J.: Princeton University Press, 1977), p. 146.

26. James Hillman, "Psychology: Monotheistic or Polytheistic," in David Miller, *The New Polytheism: Rebirth of the Gods and Goddesses* (Dallas: Spring Publications, 1981), p. 129.

27. James Hillman, *Inter Views* (New York: Harper & Row, 1983), p. 90.

28. Hillman, "The Thought of the Heart," p. 182.

29. Hillman, "Anima Mundi," p. 79.

30. Hillman, *Inter Views*, p. 111.

31. Hillman, "Image-Sense," pp. 133, 136.

32. See Martin Heidegger, *On the Way to Language*, trans. Peter Hertz (New York: Harper & Row, 1971), p. 43; cf. pp. 14 ff.

33. James Hillman, *The Myth of Analysis: Three Essays in Archetypal Psychology* (Evanston: Northwestern University Press, 1972), p. 145.

34. Martin Heidegger, *Poetry, Language, Thought*, trans. Albert Hofstadter (New York: Harper & Row, 1971), p. 25.

35. Heidegger, *On the Way to Language*, p. 14.

36. Hillman, "Image-Sense," p. 139.

37. Heidegger, *Discourse on Thinking*, p. 68.

38. See Martin Heidegger, *Kant and the Problem of Metaphysics*, trans. Janes S. Churchill (Bloomington: Indiana University Press, 1962), pp. 31 f.

IV: Language, Poetry, Art

1. Martin Heidegger, *Einführung in die Metaphysik* (Tübingen: Niemeyer Verlag, 1953), p. 11. Cited and trans. Vincent Vycinas, *Earth and Gods: An Introduction to the Philosophy of Martin Heidegger* (The Hague: Martinus Nijhoff, 1969), p. 85.

2. Vycinas, *Earth and Gods*, p. 87.

3. See Martin Heidegger, *Holzwege* (Frankfurt a/M: Klostermann, 1950), p. 286. Cf. Vycinas, *Earth and Gods*, pp. 87–88.

4. See Martin Heidegger, *On the Way to Language*, trans. Peter Hertz (New York: Harper & Row, 1971), p. 86.

5. Ibid., p. 92.

6. Ibid., p. 107.

7. Martin Heidegger, *Poetry, Language, Thought*, trans. Albert Hofstadter (New York: Harper & Row, 1971), p. 190; cf. pp. 198, 210.

8. James Hillman, "Silver and the White Earth (Part Two)," *Spring* 1981: 47.

Notes

9. Ronald Bruzina, "Heidegger on the Metaphor and Philosophy," *Heidegger and Modern Philosophy*, ed. Michael Murray (New Haven: Yale University Press, 1978), p. 194.

10. Owen Barfield, *Poetic Diction: A Study in Meaning* (Middletown, Conn.: Wesleyan University Press, 1973), p. 81.

11. See Jung, *CW* 6, §697.

12. Owen Barfield, *Saving the Appearances: A Study in Idolatry* (New York: Harcourt, Brace & World, Inc., 1965), p. 87; cf. pp. 74 ff.

13. Bruno Snell, *The Discovery of Mind* (Cambridge: Harvard University Press, 1953), p. 201.

14. See James Hillman, *The Myth of Analysis: Three Essays in Archetypal Psychology* (Evanston: Northwestern University Press, 1972), p. 7; cf. p. 128.

15. James Hillman, *Re-Visioning Psychology* (New York: Harper & Row, 1975), p. 157.

16. Ibid., p. 248, n. 24.

17. Ibid., p. 9.

18. James Hillman, "Silver and the White Earth (Part One)," *Spring 1980* : 44.

19. Barfield, *Poetic Diction*, p. 147; cf. pp. 208–09.

20. Martin Heidegger, "Hölderlin and the Essence of Poetry," *Existence and Being*, Introduction and Analysis by Werner Brock (Chicago: Henry Regnery Co., 1949), pp. 283–84.

21. See Heidegger, *Poetry, Language, Thought*, p. 216; cf. pp. 213–29.

22. Ibid., pp. 213, 218; cf. p. 226.

23. Ibid., p. 218; cf. p. 215.

24. Heidegger, "Hölderlin and the Essence of Poetry," pp. 288–89.

25. Ibid., p. 201.

26. Heidegger, *Poetry, Language, Thought*, p. 226.

27. Ibid., p. 221; cf. p. 224.

28. Ibid., p. 214.

29. Ibid., p. 220.

30. Ibid., p. 223.

31. Hillman, *Re-Visioning Psychology*, p. 13.

32. Heidegger, *Poetry, Language, Thought*, p. 226.

33. Heidegger, *On the Way to Language*, p. 166; cf. pp. 169–70.

34. James Hillman, "Image-Sense," *Spring 1979* : 139.

35. See Edward Casey, "Toward a Phenomenology of Imagination," *Journal of the British Society of Phenomenology* 5 (1974) : 10.

36. Heidegger, *Holzwege*, p. 39. Cited and trans. E. F. Kaelin, "Notes Toward an Understanding of Heidegger's Aesthetics," in *Phenomenology and*

Notes

Existentialism, ed. Edward N. Lee and Maurice Mandelbaum (Baltimore: The Johns Hopkins Press, 1967), p. 68.

37. Kaelin, "Heidegger's Aesthetics," pp. 69, 70.

38. James Hillman, "An Inquiry into Image," *Spring 1977* : 75; cf. Heidegger, *Poetry, Language, Thought*, pp. 37, 41–43.

39. See Snell, *The Discovery of Mind*, pp. 203, 224.

40. Owen Barfield, *The Rediscovery of Meaning and Other Essays* (Middletown, Conn.: Wesleyan University Press, 1977), p. 75.

41. Snell, *The Discovery of Mind*, p. 201.

42. See James Hillman, *The Dream and the Underworld* (New York: Harper & Row, 1979), p. 129.

43. Martin Heidegger, *The Piety of Thinking*, trans. James G. Hart and John C. Maraldo (Bloomington: Indiana University Press, 1976), pp. 132, 133.

44. Barfield, *Poetic Diction*, p. 182.

45. Heidegger, *Poetry, Language, Thought*, p. 127.

46. Barfield, *Rediscovery of Meaning*, p. 185.

47. Heidegger, *Poetry, Language, Thought*, p. 170.

48. Snell, *The Discovery of Mind*, p. 85.

49. Wallace Stevens, "A Primitive like an Orb," in *The Collected Poems of Wallace Stevens* (New York: Knopf, 1976), p. 440.

50. Heidegger, *Poetry, Language, Thought*, pp. 177–78.

51. David Miller, *Christs: Meditations on Archetypal Images in Christian Theology* (New York: The Seabury Press, 1981), p. xxiii.

52. Vycinas, *Earth and Gods*, p. 251.

53. Heidegger, *Poetry, Language, Thought*, p. 27.

54. See Heidegger, *On the Way to Language*, p. 43. Aesthetics as a separate discipline within philosophy was established in the eighteenth century by Gottlieb Baumgarten. In his *Reflections on Poetry* (1735) (trans. Karl Aschenbrenner and William B. Hoether [Berkeley, 1954]), a poem is said to be like a perfectly ordered whole in which nothing is superfluous or missing. Emphasis on the unity of the artwork implies aesthetic distance and separation of art from life.

55. Heidegger, *Poetry, Language, Thought*, p. 26.

56. Heidegger's most fully developed discussion of the nature of art is contained in the opening portion of *Holzwege*, two lectures on art entitled "The Origin of the Work of Art" (given in 1936), published in 1950.

57. See Heidegger, *Holzwege*, p. 35.

58. Heidegger, *Poetry, Language, Thought*, p. 17; cf. pp. 57, 71, 86.

59. George Steiner, *Martin Heidegger* (New York: The Viking Press, 1978), p. 137.

60. Heidegger, *Poetry, Language, Thought*, p. 64; cf. p. 57.

61. See Vycinas, *Earth and Gods*, p. 243; cf. *Holzwege*, pp. 22–23.

Notes

62. See James Hillman, "The Thought of the Heart," *Eranos Jahrbuch* 48—1979 (Frankfurt a/M: Insel Verlag, 1981), p. 159; cf. Plotinus, *Enneads*, 6. 7. 8.

63. Henry Corbin, *The Man of Light in Iranian Sūfism* (Boulder, Co.: Shambhala, 1978), p. 103.

64. See Henry Corbin, *Creative Imagination in the Sūfism of Ibn 'Arabi* (Princeton, N. J.: Princeton University Press, 1969), p. 162.

65. James Hillman, "Anima Mundi: The Return of the Soul to the World," *Spring 1982*: 84.

66. Hillman, "The Thought of the Heart," p. 160.

67. Heidegger, *Poetry, Language, Thought*, p. 180; cf. Walter Biemel, *Martin Heidegger: An Illustrated Study*, trans. J. L. Mehta (New York: Harcourt Brace Jovanovich, 1976), p. 108.

68. Ibid., p. 180.

69. Ibid., p. xix; cf. p. 179.

70. William J. Richardson, S. J., *Heidegger: Through Phenomenology to Thought* (The Hague: Martinus Nijhoff, 1974), p. 579.

71. James Hillman, "The Fiction of Case History: A Round," in *Religion as Story*, ed. James B. Wiggins (New York: Harper & Row, 1975), p. 132.

72. Walter Otto, *Die Götter Griechenlands* (Frankfurt a/M: Verlag G. Schulte-Bulmke, 1947), p. 161. Cited and trans. Vycinas, *Earth and Gods*, p. 213.

73. Vycinas, *Earth and Gods*, p. 232.

74. Ibid.

75. Edward Casey, "Toward an Archetypal Psychology," *Spring 1974* : 11; cf. Hillman, *The Myth of Analysis*, p. 179.

76. Hillman, *The Myth of Analysis*, pp. 175–76.

77. James Hillman, *Inter Views* (New York: Harper & Row, 1983), pp. 132–33; cf. pp. 133–36.

78. Vycinas, *Earth and Gods*, p. 196.

79. See Heidegger, *Einführung in die Metaphysik*, pp. 11, 47–48, 122–23; cf. Vycinas, *Earth and Gods*, pp. 134–73.

80. Vycinas, *Earth and Gods*, p. 149.

81. Martin Heidegger, *An Introduction to Metaphysics*, trans. Ralph Manheim (New Haven: Yale University Press, 1959), p. 14. Gadamer has observed that Heidegger's concept of the earth (*physis*) sounds "a mythical and gnostic note that at best might have its true home in the world of poetry," *Philosophical Hermeneutics*, trans. David E. Linge (Berkeley: University of California Press, 1976), p. 217.

82. Heidegger, *Einführung in die Metaphysik*, p. 87. Cited and trans. Vycinas, *Earth and Gods*, p. 141.

83. Hillman, "Fiction of Case History," p. 158.

Notes

84. Hillman, *The Myth of Analysis*, p. 280.
85. Vycinas, *Earth and Gods*, p. 209.
86. Otto, *Die Götter Griechenlands*, p. 246. Cited and trans. Vycinas, *Earth and Gods*, pp. 203–04.
87. Heidegger, *An Introduction to Metaphysics*, p. 153. Creativity or what Jung called the creative instinct is ectopsychic, "beyond" the individual soul, neither wholly in it nor of it. Hillman assigns creativity to the intermediate region of the soul, the metaxy and Eros. Eros and psyche are transpersonal powers or events belonging to the realm of archetypal reality. See *The Myth of Analysis*, pp. 36, 73–76, 104 ff.; Jung, CW 17, §305; CW 6, §197, 93; CW 7, §237 ff.

V: Play and Earth

1. See John Caputo, *The Mystical Element in Heidegger's Thought* (Athens: Ohio University Press, 1978), p. 273.
2. Ibid., p. 83.
3. Martin Heidegger, *On Time and Being*, trans. Joan Stambaugh (New York: Harper Colophon Books, 1972), p. 24.
4. James Hillman, "The Fiction of Case History: A Round," in *Religion as Story*, ed. James B. Wiggins (New York: Harper & Row, 1975), p. 132.
5. Martin Heidegger, *Der Satz vom Grund*, 3 Auflage (Pfullingen: Neske, 1965), p. 28. Cited and trans. Caputo, *The Mystical Element*, p. 52.
6. See Heidegger, *Der Satz vom Grund*, pp. 60–61.
7. Angelus Silesius, *Der Cherubinische Wandermann*, hrsg. u. eingel. v. C. Waldemar (München: Goldmann, 1960), I : 289. Cited and trans. Caputo, *The Mystical Element*, p. 61.
8. Martin Heidegger, "The Principle of Ground," trans. K. Hoeller, *Man and World* VII (1974) : 73. Cited by Caputo, *The Mystical Element*, p. 65.
9. Heidegger, *Der Satz vom Grund*, p. 188. Author's trans.
10. Ibid., pp. 101–02. Cited and trans. Caputo, *The Mystical Element*, p. 72.
11. Caputo, *The Mystical Element*, p. 65.
12. Meister Eckhart, *Die deutsche und lateinische Werke. Die deutsche Werke* (Stuttgart, 1936 ff.), II : 253 f.
13. Reiner Schürmann, "The Loss of the Origin in Soto Zen and Meister Eckhart," *The Thomist* 42/2 (April 1978) : 283.
14. "Play" is also an appropriate characterization of the process of *aletheia*. On one occasion Heidegger rephrases Leibniz's statement *"Cum Deus calculat, mundus fit"* to "while God plays, world comes to be (*Der Satz vom Grund*, p. 186).
15. James Hillman, *Re-Visioning Psychology* (New York: Harper & Row, 1975), p. 154.

Notes

16. James Hillman, "Abandoning the Child," *Eranos Jahrbuch* 40—1971 (Leiden: E. J. Brill, 1973), pp. 388–89.

17. Ibid., p. 391.

18. See Martin Heidegger, *Being and Time*, trans. John Macquarrie and Edward Robinson (New York: Harper & Row, 1962), p. 41.

19. Cited by Martin Heidegger in *An Introduction to Metaphysics*, trans. Ralph Manheim (New Haven: Yale University Press, 1959), p. 101.

20. Michael E. Zimmerman, *Eclipse of the Self: The Development of Heidegger's Concept of Authenticity* (Athens: Ohio University Press, 1981), p. 240.

21. Edward Casey, "Time in the Soul," *Spring 1979* : 158. To Heidegger, the idea of origins has nothing to do with history or science: "The knowledge of primordial history is not a ferreting out of primitive lore or a collection of bones. It is neither half nor whole of natural science but, if it is anything at all, mythology" (*An Introduction to Metaphysics*, p. 119).

22. James Hillman, *The Myth of Analysis: Three Essays in Archetypal Psychology* (Evanston: Northwestern University Press, 1972), p. 184.

23. See Martin Heidegger, *Nietzsche* I (Pfullingen: Neske, 1961), pp. 289–97, 438–47; *Vorträge und Aufsätze* (Pfullingen: Neske, 1959), 1 : 97–118.

24. Karl Kerényi, *Hermes, Guide of Souls*, trans. Murray Stein (Spring Publications, 1976), pp. 14–15; cf. p. 77.

25. See Heidegger, *Being and Time*, sec. 44 (b) and (c); Hillman, *Re-Visioning Psychology*, p. 160.

26. Martin Heidegger, *Von Wesen der Wahrheit* (Frankfurt a/M: Klostermann, 1943), pp. 22–23. Author's trans.

27. See Hillman, *Re-Visioning Psychology*, pp. 159–60. Plato describes *ananke* as "rambling," "aimless," irresponsible. Paul Friedländer suggests that *ananke* operates in the center of man as the principle of indefiniteness, unreason, and chaos. See *Plato 3*, trans. Hans Meyerhoff, Bollingen Series (Princeton, N. J.: Princeton University Press, 1969), p. 392.

28. James Hillman, "On the Necessity of Abnormal Psychology," *Eranos Jahrbuch* 43—1974 (Leiden: E. J. Brill, 1977), p. 104.

29. Hillman, *The Myth of Analysis*, p. 177.

30. Heidegger, *Schelling*, p. 18. Cited and trans. G. P. Parkes, "Time and the Soul," p. 48. Dissertation.

31. Hillman, *The Myth of Analysis*, p. 287.

32. David Miller, "Theologia Imaginalis," in *The Archaeology of the Imagination*, ed. Charles E. Winquist, Journal of the American Academy of Religion Thematic Studies 48/2 : 11.

33. David Miller, "The Two Sandals of Christ: Descent into History and into Hell," *Eranos Jahrbuch* 50—1981 (Frankfurt a/M: Insel Verlag, 1982), pp. 170, 173.

34. Hillman, *The Myth of Analysis*, p. 284.

Notes

35. C. G. Jung, *Memories, Dreams, Reflections*, ed. A. Jaffé (London: Collin and Routledge, 1963), p. 177.

36. Miller, "The Two Sandals of Christ," p. 193.

37. Ibid., p. 194.

38. F. W. Farrar, *Eternal Hope* (London, 1898), p. 66.

39. See Denzinger-Barnwart, *Enchiridion Symbolorum*, No. 211; St. Augustine, *The City of God*, Bk. XX, Chapters XXI and XXII; St. Thomas Aquinas, *Summa Theologica* Suppl., q. 94, art. 1.

40. Hillman, *The Myth of Analysis*, p. 200.

41. Ibid., p. 37.

42. Miller, "Two Sandals," p. 210.

43. Ibid.

44. Martin Heidegger, *On the Way to Language*, trans. Peter Hertz (New York: Harper & Row, 1971), p. 66.

45. Ibid., p. 153.

46. Henry Corbin, *Spiritual Body and Celestial Earth*, trans. Nancy Pearson (Princeton, N. J.: Princeton University Press, 1977), pp. xii, 4, 16, 88.

47. See Vincent Vycinas, *Earth and Gods: An Introduction to the Philosophy of Martin Heidegger* (The Hague: Martinus Nijhoff, 1969), p. 163.

48. Ibid., pp. 182-83.

49. Martin Heidegger, *Holzwege* (Frankfurt a/M: Klostermann, 1950), p. 36. Cited and trans. Vycinas, *Earth and Gods*, p. 129.

50. Vycinas, *Earth and Gods*, p. 129.

51. Heidegger, *Holzwege*, p. 36. Cited and trans. Vycinas, *Earth and Gods*, p. 129; cf. Paul Friedländer, *Plato* 1, trans. Hans Meyerhoff, Bollingen Series (Princeton, N. J.: Princeton University Press, 1958), p. 264, on "true earth."

52. Heidegger, *Holzwege*, p. 38. Cited and trans. Vycinas, *Earth and Gods*, p. 129.

53. Heidegger, *An Introduction to Metaphysics*, p. 38.

54. James Hillman, "Silver and the White Earth (Part Two)," *Spring 1981* : 23.

55. Ibid., p. 24.

56. Heidegger, *On the Way to Language*, p. 163.

57. Ibid., p. 164.

58. Ibid., p. 197.

59. James Hillman, *The Dream and the Underworld* (New York: Harper & Row, 1979), p. 5.

60. Ibid., p. 31.

61. *Letters of Rainer Maria Rilke*, Volume Two: 1910-1924, trans. J. B. Green and M. M. Norton (New York: W. W. Norton and Co., 1947), pp. 373-74.

62. Hillman, *The Dream and the Underworld*, p. 45.

Notes

63. See James Hillman, "Dionysus in Jung's Writings," *Spring 1972* : 201. In Shamanistic rituals, the neophite becomes "a soft man being," i.e., an androgyne whose essential mission is to be an intermediary between the cosmological planes of earth and sky. It is said that the effort to incorporate this paradox involves the shaman in "the constant practice of transformation, as if moving from one point of view to another provides the experimental ground of understanding, of wisdom of true perspective" (Joan Halifax, *Shamanic Voices: A Survey of Visionary Narratives* [New York: Dutton, 1979], p. 28).

64. Heidegger, *On the Way to Language*, pp. 171,. 172.

65. Ibid., p. 179.

66. Ibid., p. 180; cf. *Discourse on Thinking* (New York: Harper & Row, 1966), pp. 47–49.

67. James Hillman, "Peaks and Vales," *Puer Papers* (Spring Publications, 1979), p. 64; cf. pp. 59 ff; cf. *Re-Visioning Psychology*, pp. 69 ff.

68. Heidegger, *On the Way to Language*, p. 194.

69. Ibid., p. 185.

70. Ibid., pp. 166, 171.

71. James Hillman, "Alchemical Blue and the *Unio Mentalis*," *Sulfur* 1 (1981) : 43.

72. Kurt Badt, *The Art of Cézanne* (Berkeley and Los Angeles: University of California Press, 1965), p. 56.

73. Hillman, "Alchemical Blue," p. 44.

74. Martin Heidegger, *Unterwegs zur Sprache* (Pfullingen: Neske, 1965), pp. 51, 69, 71. Author's trans.

75. Corbin, *Spiritual Body and Celestial Earth*, p. 88; cf. p. xii. The Mazdean perception of the Earth and Zoroastrian angelology are contained in the *Avesta*, particularly in the *Gathas* of Zarathustra (see ibid., pp. 3, 5). The ontological status of the angels of Mazdean piety is quite different from that of the Biblical or Koranic angels; the Mazdean angels are neither servants nor messengers but rather "figures homologous to the *Dii-angeli* [angel-gods] of Proclus" (ibid., p. 6). In Proclus the *dii-angeli* are the hermeneuts of the hidden deity.

76. Ibid., p. 4.

77. Ibid., p. 20. Gustav Theodore Fechner, the nineteenth-century German scientist turned visionary and author of a philosophical work entitled *Zend-Avesta*, reports a vision of his in which the earth is revealed as an angel: "On a certain morning I went out to walk. The fields were green, the birds sang, the dew glistened, the smoke was rising, here and there a man appeared; a light as of transfiguration lay on all things. It was only a little bit of the earth; it was only one moment of her existence; and yet as my look embraced her more and more it seemed to me not only so beautiful an idea, but so true and clear a fact,

149

Notes

that she is an angel, an angel so rich and fresh and flower-like, and yet going her round in the skies so firmly and so at one with herself, turning her whole living face to Heaven, and carrying me alone with her into that Heaven, that I asked myself how the opinions of men could ever have so spun themselves away from life so far as to deem the earth only a dry clod, and to seek for angels above it or about it in the emptiness of the sky—only to find them nowhere. . . . But such an experience as this passes for fantastic (*Über die Seelenfrange* [1891], p. 170, cited by William James, *A Pluralistic Universe* [New York: Longmans, Green, and Co., 1932], p. 164).

78. James Hillman, "Silver and the White Earth (Part Two)," *Spring 1981* : 25.

79. James Hillman, "Silver and the White Earth (Part One)," *Spring 1980* : 23.

80. Ibid., p. 30.

81. Ibid., p. 26.

82. Ibid., p. 27.

83. Hillman, "Silver and the White Earth (Part Two)," p. 22.

84. Ibid., p. 28.

85. Ibid., p. 27.

86. Hillman, "Silver and the White Earth (Part One)," pp. 45–46.

87. Jung, *Memories, Dreams, Reflections*, p. 240.

88. Hillman, "Silver and the White Earth (Part Two)," p. 50.

89. Joan Stambaugh, "Introduction," in Heidegger, *On Time and Being*, p. x.

VI: Releasement

1. James Hillman, "Silver and the White Earth (Part One)," *Spring 1980* : 28.

2. Martin Heidegger, *Discourse on Thinking*, trans. John M. Anderson and E. Hans Freund (New York: Harper & Row, 1966).

3. The Jungian "active imagination" must be distinguished from the Freudian technique of "free association" which is based on the premise that all significant imagining represents the fulfillment of certain infantile wishes. Active imagination is a purposive turning to the transpersonal unconscious which, according to Jung, is not only the basis of the conscious mind but also the subjective or inner aspect of nature. In active imagination we are expected to recognize the "otherness" and the genuine autonomy of an objective impersonal psyche. The images appearing during this activity must be allowed to speak for themselves, to have a life of their own; the ego's task is to be an onlooker and at the same time to be involved—akin to the attitude of a playgoer watching a moving stage drama. Eventually one is led to experience a

Notes

new level of being—a world in which the ego participates not as director but as the actively experiencing one. Active imagination must be also distinguished from ordinary conscious imagining—or mere fancy, daydreams, and reveries—which Jung ranges under the rubric of "passive fantasy" and which is dominated by the imaginer's ego. For reference, see R. F. C. Hull, "Bibliographical Notes on Active Imagination in the Works of C. G. Jung," *Spring 1971* : 115-20.

 4. Cited by Mary M. Watkins, *Waking Dreams* (New York: Harper Colophon Books, 1977), p. 43. Reprinted, Spring Publications, 1984.

 5. Watkins, *Waking Dreams*, p. 21.

 6. James Hillman, *Archetypal Psychology: A Brief Account* (Dallas: Spring Publications, 1983), p. 7.

 7. Martin Heidegger, *Identity and Difference*, trans. Joan Stambaugh (New York: Harper Torchbooks, 1969), p. 66.

 8. Reiner Schürmann, "Heidegger and Meister Eckhart on Releasement," in *Research in Phenomenology*, ed. John Sallis (Duquesne University/Humanities Press, 1973), III : 103.

 9. Huston Smith, "Perennial Philosophy, Primordial Tradition," *International Philosophical Quarterly* 22/2 (June 1982) : 130.

 10. Ludwig Wittgenstein, *Philosophical Investigations*, p. 255; cited by Smith, "Perennial Philosophy, Primordial Tradition," p. 131, n. 21.

 11. Reiner Schürmann, *Meister Eckhart: Mystic and Philosopher* (Bloomington: Indiana University Press, 1978), p. 19.

 12. Jacob Needleman, *Consciousness and Tradition* (New York: Crossroad, 1982), p. 5.

 13. Heidegger, *Discourse on Thinking*, p. 61.

VII: While the Music Lasts

 1. James Hillman, "Back to Beyond: On Cosmology," unpublished paper presented at the Conference "Whitehead, Jung and Hillman," Center for Process Studies, Claremont, Calif., February 1983, typescript p. 4.

 2. Ibid., p. 10A.

 3. Henry Corbin, *Creative Imagination in the Sufism of Ibn 'Arabi* (Princeton, N. J.: Princeton University Press, 1969), p. 4.

 4. See James Hillman, "Egalitarian Typologies *versus* the Perception of the Unique," *Eranos Jahrbuch* 45—1976 (Leiden: E. J. Brill, 1980), p. 258.

 5. Corbin, *Creative Imagination*, p. 180.

 6. Edward Casey, "Toward an Archetypal Psychology," *Spring 1974* : 21.

 7. Ibid., p. 20. See Kathleen Raine, *The Divine Vision* (New York: Haskell House, 1968) and *Blake and Tradition*, 2 vols. (London: Routledge and Kegan Paul, 1969).

Notes

8. Henry Corbin, *Spiritual Body and Celestial Earth*, trans. Nancy Pearson (Princeton, N. J.: Princeton University Press, 1977), p. 102.

9. Ibid., p. 174.

10. Henry Corbin, "Cyclical Time in Mazdaism and Ismailism," *Man and Time: Papers from the Eranos Yearbooks* 3 (Princeton, N. J.: Princeton University Press, 1957), p. 165.

11. Nasīraddin Tūsī, *Taswuurāt*, pp. 36–60. Cited by Corbin, "Cyclical Time," p. 165.

12. Corbin, "Cyclical Time," p. 166.

13. Tūsī, *Tasawuurāt*, p. 60. Cited by Corbin, "Cyclical Time," p. 166, n. 89.

14. W. B. Yeats, *If I Were Four-and-Twenty* (Dublin: The Cuala Press, 1940), p. 30.

15. Emanuel Swedenborg, *Heaven and Its Wonders and Hell* (New York: Swedenborg Foundation, 1977), §553; cf. §552.

16. Emanuel Swedenborg, *Angelic Wisdom Concerning the Divine Love and the Divine Wisdom* (New York: Swedenborg Foundation, 1976), §11.

17. William Blake, *Blake: Complete Writings*, ed. Geoffrey Keynes (London: Oxford University Press, 1966), p. 804.

18. Raine, *Blake and Tradition*, vol. 1, p. 422, n. 38.

19. Kathleen Raine, *The Human Face of God: William Blake and the Book of Job* (New York: Thames and Hudson, Inc., 1982), p. 47.

20. Corbin, *Creative Imagination*, p. 271.

21. Ibid., p. 378, n. 4.

22. Jacob Needleman, *Consciousness and Tradition* (New York: Crossroad, 1982), p. 5.

23. Angelus Silesius, *Der Cherubinische Wandersmann*, hrsg. v. eingel. v. C. Waldemar. Goldmanns Gelbe Tachenbücher (München: Goldmann, 1960), I : 8. Cited and trans. John Caputo, *The Mystical Element in Heidegger's Thought* (Athens: Ohio University Press, 1978), p. 126.

24. C. G. Jung, *Memories, Dreams, Reflections*, ed. A. Jaffé (London: Collin and Routledge, 1963), p. 177.

25. C. G. Jung, *Letters*, ed. G. Adler and A. Jaffé, Bollingen Series (Princeton, N. J.: Princeton University Press, 1973), I : 65–66.

26. Jung, *CW* 11, §139; cf. §141.

27. Jung, *CW* 9i, §634; *CW* 11, §80–82.

28. Hillman, "Typologies *versus* the Unique," pp. 26–61.

29. John Caputo, *Heidegger and Aquinas: An Essay on Overcoming Metaphysics* (New York: Fordham University Press, 1982), p. 206.

30. Ibid., p. 204.

31. See Martin Heidegger, *Holzwege* (Frankfurt a/M: Klostermann, 1950), p. 368; cf. p. 355.

Notes

32. Raine, *The Human Face of God*, p. 39.

33. Martin Heidegger, *On Time and Being*, trans. Joan Stambaugh (New York: Harper Colophon Books, 1972), p. 30.

34. Blake, *Complete Writings*, pp. 355-56.

35. Swedenborg, *Divine Love and Wisdom*, §160.

36. Martin Heidegger, *Nietzsche* II (Pfullingen: Neske, 1961), p. 28. Cited and trans. Caputo, *The Mystical Element*, p. 141.

37. Martin Heidegger, *Frühe Schriften* (Frankfurt a/M: Klostermann, 1962), p. 253. Author's trans.

38. Friedrich Nietzsche, *The Will to Power*, trans. W. Kaufmann and R. J. Hollingdale (New York: Vintage Press, 1967), p. 20.

39. See Martin Heidegger, *On the Way to Language*, trans. Peter Hertz (New York: Harper & Row, 1971), pp. 106, 108.

40. Martin Heidegger, *Der Satz vom Grund*, 2nd ed. (Frankfurt a/M: Klostermann, 1957), p. 144. Author's trans.

41. For a comparison between Heidegger and Eckhart, I am indebted to John Caputo's *The Mystical Element in Heidegger's Thought* and Reiner Schürmann's *Meister Eckhart: Mystic and Philosopher* (Bloomington: Indiana University Press, 1978).

42. Caputo, *The Mystical Element*, p. 156.

43. Martin Heidegger, *Die Technik und die Kehre* (Pfullingen: Neske, 1962). "The Turning," trans. K. R. Maly, in *Research in Phenomenology* I (Pittsburgh: Duquesne University Press, 1971) : 79/7.

44. Caputo, *The Mystical Element*, p. 162.

45. Schürmann, *Meister Eckhart*, p. 29.

46. Ibid., pp. 29-30.

47. Reiner Schürmann, "The Loss of the Origin in Soto Zen and Meister Eckhart," *The Thomist* 42/2 (April 1978) : 302.

48. Martin Heidegger, *Identity and Difference*, trans. Joan Stambaugh (New York: Harper Torchbooks, 1969), p. 31.

49. Caputo, *The Mystical Element*, p. 173.

50. James Hillman, "Abandoning the Child," *Eranos Jahrbuch* 40—1971 (Leiden: E. J. Brill, 1973), p. 383.

51. See James Hillman, "An Inquiry into the Image," *Spring 1977* : 68.

52. James Hillman, "Silver and the White Earth (Part Two)," *Spring 1981* : 57-58.

53. Ibid., p. 59.

54. Ibid., p. 57.

55. James Hillman, "Psychology: Monotheistic or Polytheistic," in David L. Miller, *The New Polytheism: Rebirth of the Gods and Goddesses* (Dallas: Spring Publications, Inc., 1981), pp. 115-16.

56. Jung, *CW* 14, §47; cf. *CW* 8, §388 ff.

Notes

57. Hillman, "Psychology: Monotheistic or Polytheistic," p. 120; cf. p. 114.

58. Miller, *The New Polytheism*, p. 50.

59. Diana L. Eck, *Darśan: Seeing the Divine Image in India* (Chambersburg, Penn.: Anima Books, 1981), p. 19; cf. p. 34.

60. Miller, *The New Polytheism*, p. 119.

61. Hillman, "Psychology: Monotheistic or Polytheistic," p. 119.

62. Walter Otto, *Die Götter Griechenlands* (Frankfurt a/M: Verlag G. Schulte-Bulmke, 1947), p. 168. Cited and trans. Vincent Vycinas, *Earth and Gods: An Introduction to the Philosophy of Martin Heidegger* (The Hague: Martinus Nijhoff, 1969), p. 176.

63. Vycinas, *Earth and Gods*, p. 176.

64. Ibid., p. 219.

65. Pindar, "Eighth Pythian Ode," in *Odes* (Chicago: The University of Chicago Press, 1947), p. 80.

66. Martin Heidegger, "Letter on Humanism," in *Philosophy in the Twentieth Century: An Anthology*, ed. William Barrett and Henry D. Aiken (New York: Random House, 1962), 3 : 296.

67. Martin Heidegger, *Discourse on Thinking*, trans. John M. Anderson and E. Hans Freund (New York: Harper & Row, 1966), p. 58.

68. James Hillman, *Re-Visioning Psychology* (New York: Harper & Row, 1975), p. 175.

69. Ibid., p. 140.

70. Heidegger, *Identity and Difference*, p. 72.

71. Henry Corbin, "A Prefatory Letter," in Miller, *The New Polytheism*, p. 2.

72. Ibid., p. 2.

73. Ibid., p. 3.

74. Corbin, *Creative Imagination*, p. 233.

75. Ibid., p. 121.

76. Henry Corbin, "Divine Epiphany and Spiritual Birth in Ismailian Gnosis," *Man and Transformation: Papers from the Eranos Yearbooks* 5 (Princeton, N. J.: Princeton University Press, 1964), pp. 70–71.

77. Corbin, "A Prefatory Letter," p. 3.

78. Ibid., p. 4.

79. James Hillman, "Silver and the White Earth (Part Two)," p. 25.

80. Miller, *The New Polytheism*, p. 68.

81. Vycinas, *Earth and Gods*, p. 317.

82. Martin Heidegger, *Poetry, Language, Thought*, trans. Albert Hofstadter (New York: Harper & Row, 1971), p. 178.

Bibliography

Avens, Roberts. *Imagination is Reality: Western Nirvana in Jung, Hillman, Barfield and Cassirer.* Spring Publications, Inc., 1980.

———. *Imaginal Body: Para-Jungian Reflections on Soul, Imagination and Death.* University Press of America, 1982.

———. "Heidegger and Archetypal Psychology," *International Philosophical Quarterly,* June 1982.

Corbin, Henry. "De Heidegger à Sohrawardī," *Henry Corbin,* Les Cahiers de L'Herne, Paris, n.d.

———. *Creative Imagination in the Sūfism of Ibn 'Arabi.* Princeton, N. J.: Princeton University Press, 1969.

———. *Spiritual Body and Celestial Earth: From Mazdean Iran to Shi'ite Iran.* Translated by Nancy Pearson. Princeton, N. J.: Princeton University Press, 1977.

Heidegger, Martin. *Being and Time.* Translated by John Macquarrie and Edward Robinson. New York: Harper & Row, 1962.

———. *Discourse on Thinking.* A translation of *Gelassenheit* by John M. Anderson and E. Hans Freund. New York: Harper & Row, 1966.

———. *Martin Heidegger: Basic Writings.* Edited, with General Introduction and Introductions to Each Section, by David Farrell Krell. New York: Harper & Row, 1977.

Hillman, James. *Re-Visioning Psychology.* New York: Harper & Row, 1975.

———. *The Myth of Analysis: Three Essays in Archetypal Psychology.* Evanston: Northwestern University Press, 1972.

———. *The Dream and the Underworld.* New York: Harper & Row, 1979.

———. *Archetypal Psychology: A Brief Account (Together with a Complete Checklist of Works).* Dallas: Spring Publications, Inc., 1983.

———. *Inter Views.* New York: Harper & Row, 1983.

Mehta, J. L. *Martin Heidegger: The Way and the Vision.* Rev. ed. Honolulu: The University Press of Hawaii, 1976.

Miller, David L. *The New Polytheism: Rebirth of the Gods and Goddesses.* Prefatory letter by Henry Corbin. Appendix by James Hillman ("Psychology: Monotheistic or Polytheistic"). Dallas: Spring Publications, Inc., 1981.

Wilson, Peter Lamborn. *Angels.* New York: Pantheon Books, 1980.

ABOUT THE AUTHOR

Roberts Avens is a Latvian poet and Professor Emeritus of Religious Studies at Iona College. He is the author of *Imaginal Body: Para-Jungian Reflections on Soul, Imagination, and Death* and two popular works in psychological philosophy, *Imagination Is Reality: Western Nirvana in Jung, Hillman, Barfield, and Cassirer* and *The New Gnosis: Heidegger, Hillman, and Angels.*